exposures

exposures

exposures

Manuel Vason
Lois Keidan
Ron Athey

exposures
Lois Keidan

When we saw Manuel's polaroids, we thought, it's our work.
DogonEfff

*Exposures is a body of work about a body of work about the
body in Live Art.*

*This collection of photographs by Manuel Vason is an
unprecedented approach to the representation of artists and
their art and an intriguing introduction to some of the most
celebrated performance practitioners from the current
generation of British-based artists.*

*Created through a series of unique collaborations between
photographer and artist, the images in Exposures are intended
to be neither performance documentation nor straightforward
portraiture but something else altogether: something arguably
more attesting and arresting.*

*Collectively the artists who have collaborated on Exposures
represent some of the most exciting and provocative in Britain
today. These are artists engaged with sophisticated and
complex interrogations into the nature of contemporary art and
into questions of physicality, identity, difference and 'the
forbidden'. More specifically, these are artists who by, centring
on the body as the material of their practice and the site of
their enquiry, inspire and enthrall whilst they simultaneously
break rules and ruffle feathers.*

*Almost inevitably these are artists who provoke debate, but it
is often in ways that are at odds with the integrity of the work
itself. It could be argued this is because such innovative
practices are, for the most part, known to a wider public by
reputation rather than by experience and because they often
figure more as weird blips on the radar of public*

*consciousness than as a vital part of our cultural currency. The
challenges of how intrinsically, essentially, live practices can
be both represented and documented beyond the real time of
the action itself is the subject of heated debates in
performance circles and one of the questions Exposures hopes
to address in its attempt to find a way of 'looking' at the body
in a body of work.*

*Although it can sometimes appear like a curio in contemporary
commentary and a footnote in the approved narratives of art
history, the processes and practices of performance art have
unquestionably impacted on the cultural landscape of the
twentieth century – think Duchamp, Beuys, Warhol. And in
looking at the artists in Exposures we have to acknowledge the
noble history of the exposed and explicit body in performance.
In the radical work of the Viennese Aktionists, Gina Pane, Chris
Burden, Stelarc and Marina Abramovic we see the way that
artists turned to the body – often by performing extreme acts
upon their bodies – to contest political readings of 'the body'
or signify 'the body politic' itself.*

*The practices of the artists in Exposures is informed by these
legacies and continues these traditions, but is also work born
of different times, of different agendas, and of different
processes and practices.*

*Like the fiercely politicised East Village performance world of
1980s New York, it represents another chapter. This is work
developed against the backdrop of the urgent politicisation
of the body in relation to issues of identity, the AIDS
pandemic and global trends towards the Disneyfication of
difference. Whilst earlier artists used their bodies more as
signifiers of 'the body' or 'the body politic', many
contemporary artists are just as concerned with 'this body',*

'my body' and all it can be and do in the new world order of the twenty-first century.

But this is also work that draws on a broader pool of disciplines, approaches and cultures; work that is informed by the gene pool of the late twentieth century practices and ideas in which a range of artists and ideas collided, crossed each others' paths, blurred each others' edges and opened up the possibilities of new sites and new forms – a difference signified by a shift in language from performance art to Live Art.

And Live Art, in 2001, is not only "in a state of rude health" but is also widely acknowledged as one of the most vital and influential of creative spaces: it is the research engine of our culture where borders are disrupted and rules are broken, where new possibilties are imagined and new discourses are formed.[1] Live Art's ability to move fluidly and eloquently across genres, ideas and experiences, singles it out as an area of practice that is uniquely equipped to reflect and to negotiate the intricate tapestry of modern lives and times.

Live Art operates in the cracks in our culture, in the kinds of places synonymous with the innovation, risk and dissent inherent in radical ideas. And these are potent places where, in the early 1990s, "those who had once been disembodied voices became visible and claimed a place on the public stage".[2] And within this, artists working with the body at the centre of their practice are making highly charged, often explosive, work. By using their bodies as cultural and political signifiers and by privileging the real over the representational they are revealing the body in all its diversities, difficulties, desires and dirt and forcing contact with it as "it is and not necessarily as it is imagined".[3]

In the 1990s a new generation of Black and Asian British artists emerged from a range of disciplines and converged on the body/their bodies in performance as sites to negotiate the politics of difference and contest post colonial representations

of 'the other'. Defying expectations to "perform their ethnicity", Ronald Fraser Munroe, Susan Lewis and Moti Roti are but a few contemporary artists who draw on a diversity of strategies, practices, forms and traditions to construct compelling new representations of the complexity of the British experience that, in turn, contribute to broader debates around assimilation and hybridity in multi-cultural Britain.

Interdisciplinary and cross disciplinary artists like Mat Fraser, Aaron Williamson, Helena Goldwater, Stacy Makishi, Marisa Carnesky and Oreet Ashery work with the physicality of the body to re-appropriate the gaze or challenge perceptions of difference, intolerance and received roles. With wit, charm and subtlety as much as outright militancy, their work engages with issues and experiences spanning disability, displacement, belonging and transgression – raw issues that are central to the plurality of contemporary times, and real experiences that belie the all conquering homogeniety of Nike and the myopia of Middle England.

Other Exposures collaborators such as La Ribot, Gilles Jobin, Ernst Fischer, DogonEfff and Joshua Soafer, are working with ideas of the body not so much as cultural signifiers – a personalised identity framework – but as the site of an enquiry; the material, the tool of their distinct and diverse practices. Here the body is one to be moulded, manipulated, probed, released and 'inserted' into cultural spaces and social contexts, be they the gallery, the theatre, the screen or the public place.

And then there are artists featured in Exposures who are engaged with more testing, visceral aspects of the body in society and society in the body. Revealing the hidden and the forbidden at their most raw and intimate, the practices of Franko B, Kira O'Reilly, Giovanna Maria Casetta, Robert Pacitti and Doran George can be at once brutal, beautiful and captivating, involving rare levels of exposure, endurance and transgression.

Practices that open up and expose the body in this way could be said to be not so much beautiful as sublime. Jonathan Jones referred to Edmund Burke's understanding of the sublime as:

beauty's dark double. Where the beautiful conforms to an idea of perfection, order and harmony, the sublime achieves a comparably powerful emotional effect by astonishing, shocking and overpowering us... we are more moved by the sublime than the beautiful because the idea of pain are much more powerful than those which enter on the part of pleasure.[4]

Beauty's dark double indeed. However, the sublime ideas represented in Exposures are not just about the body, they become real through the body, and this has, as indicated earlier, consequences for their perception and reception. You could say such work is as much about the process of bleeding as blood itself, and it is this question of form that continues to challenge the framing and representation of much Live Art practice.

Live Art is as much about the actuality of the idea, the acting it out, as the concept itself, and distinctions between the real and the representational determine all kinds of ways in which art is, and can be, framed and read. Live Art is inherently, defiantly, in conflict with conventional artistic strategies and approaches and has therefore come to represent one of the few unmediated and uncontrolled sites we have left in contemporary culture. Live Art's very nature/s resists commodification and defies 'a market'; it can't be appropriated, packaged or redistributed for mass consumption. It's a free agent; unbranded and unbrandable.

But the downside is that such distinctions have implications for how Live Art is recorded, archived and critiqued. Live Art is an active process; it is about immediacy and presence and exists in and of the moment. Live Art is inherently, intrinsically, ephemeral; it is neither fixed nor scored and all it leaves are traces, relics, images, documents, memories and commentaries, none of which are, or should be, confused with the

performance itself. Schools of theory and numerous ground breaking projects have long addressed the problematical and contradictory processes of 'reading' and representing performance after the act. Peggy Phelan argues that "performance cannot be saved, recorded, documented, or otherwise participate in the circulation of representations of representations: once it does so it becomes something other than performance".[5] Adrian Heathfield's seminal collection of fragments and documents, Shattered Anatomies, asked "what issues are at stake in the translation of live art into dead records?"[6] The Out of Actions exhibition set out to write performance art into the canon of art history and in doing so accelerated debates as to what was being written in — the object or the subject, of photographic documentation.[7]

So, how do you celebrate or even negotiate these kinds of practices 'out of actions' and in ways that are not mistaken for 'the thing' itself? Exposures suggests another possible approach. In developing Exposures, Manuel Vason has found a way to work with artists on constructing photographic representations, not of performances, but of the essence of the artists' practice. These are images that understand the visceral and visual potency of the body in Live Art but that attempt to signify the ideas rather than document their actuality.

I feel the images have captured an essence of the work which is often missing in it's documentation.
Giovanna Maria Casetta

Ron Athey suggests that a photographic relationship can never be 100% collaborative and that a photograph itself is incapable of telling the whole story and, understandably, some artists approached Exposures with trepidation.

The making of the images resided in an uneasy and ambiguous place somewhere between documenting, performance and fashion shoot.
Kira O'Reilly

The Leibowitz Vanity Fair spread Athey refers to is one of the many precedents for this project, but one in which the images seemed to be exclusively Leibowitz's, based more on her fetishisation of the artists' work than a shared insight into their practice. And photography, in being unable to "tell the whole story" of a performance, can also be both a glamourising and reductionist process.

I'm a bit insecure about 'staged photography' in relation to performance when the photographer and not the artist is the figurative author since all past works that have tried this route end up as coffee table books.
Aaron Williamson

To the delight of all concerned the process of creating Exposures proved not to be about staging or shooting performances as such but an attempt at a much more collaborative way of working. Through a process of dialogues and experimentation, and particularly the use of 10 x 8 Polaroids, Manuel has somehow captured something of the artists' relationship to their work and offered a rare, frozen, glimpse of the artist within their practice.

By creating images for camera, the collaborators have dispensed with the problematics of time, space and action inherent in performance documentation and achieved something else.

Manuel and I shot these images and the sequence revealed itself. They became performances in themselves, unique to this book, to Manuel and I.
Helena Goldwater

For some artists the shoots became a site to further interrogate the concerns of their work in relation to the politics and processes of identity construction –
Embedded within the formality, symmetry and neatness of these images, is a layering of cultural encoding and referencing which

parallel our work practices. They are at once familiar and unexpected.
Moti Roti

– and a site to both contest the gaze of the camera and problematise 'the look':

In these images my body is art because the use of photographic style, the confrontation of my body with the viewer, renders it so.
Mat Fraser

For others the project became a performance in its own right, a part of their practice:

The way in which these photographs perform is of particular relevance to my arts practice which is concerned with the relationship between the 'event' and the 'archive' between the temporal and its representation.... These photographs became another site for work; not reflecting or promoting some other piece but performative photographs themselves.
Joshua Sofaer

Exposures has been an act of passion on the part of a former fashion photographer who first came into contact with Live Art when collaborating with Franko B on I Miss You!, a blood performance in the form of a catwalk show. His enthusiasm and integrity has been well met by that of the collaborating artists in their generosity and honesty in creating difficult, sometimes demanding images for Manuel, for the camera and for this book.

The images they have developed simultaneously satisfy and intrigue; they capture your attention and imagination but also leave you wanting to know more, asking questions. In an effort to go beyond the images on the page, the collaborating artists have contributed texts about their work, the ideas that inform it and how those are represented in Manuel's photographs.

Seen together, their writings are as diverse and eclectic as the presence of the body in Live Art is itself but, we hope, also suggest another way of approaching the ideas represented in these photographs.

1 Robert Ayers, National Review of Live Art Catalogue, *2001*

2 Karen Finley, A Different Kind of Intimacy,
 Thunders Mouth Press, 2000

3 C. Carr, On Edge, *Wesleyan University Press, 1993*

4 Jonathan Jones, The Guardian, *July 2000*

5 Peggy Phelan, Unmarked, *Routledge, 1993*

6 Adrian Heathfield, Andrew Quick, Fiona Templeton,
 Shattered Anatomies, *Arnofini Live, 1997*

7 Out Of Actions, *Thames & Hudson, 1998*

Some thoughts on the politics of the body and the problematics of documentation
Ron Athey

Why do I choose to make disturbing images? This is the question, more accusatory than curious, that never goes away. In that famished and vulnerable state after a performance, sometimes shocked at what my own work has revealed to me, I take the prospect of my guilt seriously, and try to be honest and gentle, whether they deserve it or not. But I struggle for the answer, I sound mad explaining my inner visions and nightmares that somehow I feel compelled to share. Since I started by making performance in a time of plague, I find these words of Antonin Artaud from The Theatre and Its Double, *articulate what I can't quite spit out:*

Like the plague the theatre is the time of evil, the triumph of dark powers that are nourished by a power even more profound until extinction.... The theatre, like the plague, is in the image of this carnage and this essential separation. It releases conflicts, disengages powers, liberates possibilities, and if these possibilities and these powers are dark, it is the fault not of the plague nor of the theatre, but of life.

So it wasn't the fault of the art movement I never belonged to, or the sick mentors who encouraged me, it is the fault of my rotten life: the Grapes of Wrath darkness that was fatherless, an institutionalised schizophrenic mother, a fundamentalist Pentecostal upbringing by relatives, a decade of drug addiction followed by 15 years of HIV infection. Living those days in a grim suburb where white flight left only poor blacks, Chicanos, and illegal aliens; followed by Vietnam boat refugees, and victims of the US sponsored civil war in El Salvador. Where would I find the drive to make work that's light and gentle? A perfectly depicted apocalypse does pull the punch, somewhat.

Defying expert consensus, the mixing of art and politics have produced some of the best work of the last two decades. By the late 80s, the AIDS pandemic charged the work of Karen Finley and David Wojnarowicz with a power not likely to be found in kinder times. On a more studied front, Ron Vawter's two-act Roy Cohn/Jack Smith was a fierce portrayal of two very different and contradictory characters whose only link was that they died from AIDS in the same year. And the sexual backlash from this period caused for some sex positive movements such as Annie Sprinkle's Post-Porn Modernist which elevated the pro-sexualised woman to new heights and changed the world (not to mention slipping in some safe sex and transgender awareness messages). Guillermo Gomez Pena and Coco Fusco's The Couple In The Cage nailed our latent, or persistent, exoti-philia and collective colonial guilt when they toured the art institutions of the world in a display cage as specimens of a new found tribe. But because of the history of the twentieth century, pieces are not always so clearly defined and images can resonate with information whether intended or not: an emaciated naked body conjures Auschwitz and AIDS, and, particularly in the States, a submissive black body evokes the history and aftermath of slavery.*

Taking up this vein I found an Allen Ginsberg essay from 1959 particularly relevant to mass consumption, titled "Poetry, Violence, and the Trembling Lambs or Independence Day Manifesto":

The only immediate historical data that we can know and act on are those fed to our senses through systems of mass communication. These media are exactly the places where the deepest and most personal sensitivities and confessions of reality are most prohibited, mocked, suppressed. At the same time there is a crack in the mass consciousness of America — sudden emergence of insight into a vast subconscious netherworld filled with nerve gases, universal death bombs,

malevolent bureaucracies, secret police systems, drugs that open the door to God, ships leaving Earth, unknown chemical terrors, evil dreams at hand. Because systems of mass communication can communicate only officially acceptable levels of reality, no one can know the extent of that secret unconscious life.

It is a Burroughsian perspective, but given optimism as only a Jewish Buddhist could. Add 42 years, a couple of fierce civil rights movements, feminism, backlash, MTV, the World Wide Web and globalism; the point is still relevant but even mushier, we are post-cut'n'paste. The underground press that fueled so many movements of the 60s and 70s and served as the counterpoint to the officially acceptable levels of realities (which now have to be entertaining as well) has gone upwardly mobile or despondent. Too much of the wrong information is almost better than none at all, but there's no truth in either. How has access to unlimited information not created more enlightenment, more compassion?

This generation's radical youth culture icon, Marilyn Manson, has, with the help of an art direction team, consumed and polished the images of numerous extreme and marginalised artists and then gone and endorsed the conservative shit-for-brains George W. Bush presidency. Manson's usurping of the trademark images of radical artists and transgendered pop stars isn't subversive, it's co-option and profiteering. I'm aware there's a contingent that admire Manson's 'gall' for pushing the gender envelope within the mainstream, but remember a eunuch is harmless. I think MTV ruined anything underground: the demand for imagery made the idea of trademark images obsolete and art direction teams began using artists' books as public domain reference material. This filtered up to Hollywood and blockbusters like The Cell should be paying out royalties to every artist they've ripped off.

So I suppose that means if imagery isn't dumbed down, sped up and dulled for the masses, it's considered too haughty,

precious, or marginalised to be validated by mainstream communications systems. But to disregard context is a jaded point of view and images from an artist's performance simply shouldn't be at the disposal of a Jennifer Lopez vehicle or a Republican rock star. In the US, while photography and written word have extensive copyright protection, trademark image is so vague most courts of law wouldn't begin to take it on.

In regards to a photograph, this brings to mind ownership: whose image is it? I've long seen photography problematic in this regard and something that could never be 100% collaborative. An artist's body and symbols are not a model and a set, they are their life. Annie Leibowitz attempted a kind of photographic collaboration in her Vanity Fair portraits of the 70 year old grand dame of performance, Rachel Rosenthal, buried up to her neck in desert sand; shrei opera diva Diamanda Galas clad in loin cloth on a burning cross; and monologist Karen Finley reclining naked except for thick fuzzy socks. But Leibowitz's work was based on her interpretation of the artists and their signatures rather than on the artists' actual work; the images were hers.

Documenting Live Art is problematic in that it doesn't tell the whole truth. The captured photographic image is often misleading, but nonetheless stands as evidence. What's lost is the live ambiance, the soundtrack, words, suspense, and the wind down or finale. And then performance is made for an audience, not a camera angle. While more 'consumable' than performance, photography has a bad rap. It can preserve a statement for eternity, but it's also known to lie, cheat and steal. These are serious obstacles the photographer has to grapple with. On the flipside, it takes ambition and patience to produce a book full of different artists, and photography books have, I admit, introduced me to so many artists, new and old.

I find institutionalised art with a few exceptions to be a corporate snore, more based on hype and PR than content.

Call me obvious, but I need strong images and 'messages' that leave me thinking about them and feeling them. As opposed to an installation, Live Art often uses a more 'theatrical' tradition and sets up a demand for total attention. Whether it be esoteric or didactic, when this much attention is called to an image, there is some sort of testimonial. This is where performance gets into the ritual/transformation territory. Performance straddles a space as illusory as it can be embarrassingly real, made more authentic through real-time slip-ups: an unscripted gasp of breath, an un-choreographed tremor of flesh. Sometimes an enduring image forces me to process it in a way that's slow, like meditation; or fast, like a Rorschach test.

In this collection of photographs by Manuel Vason of radical British-based practitioners of Live Art what seems to be a through-line in the work is the re-examining of cultural signifiers. This body of work makes clear that at this time there is a vital, varied and vocal Live Art scene in the UK. It's also apparent that it has not all been seen and said and done. It is crucial for me to know that there are new fresh voices and profoundly different ways of expressing this perception we live in.

picture index

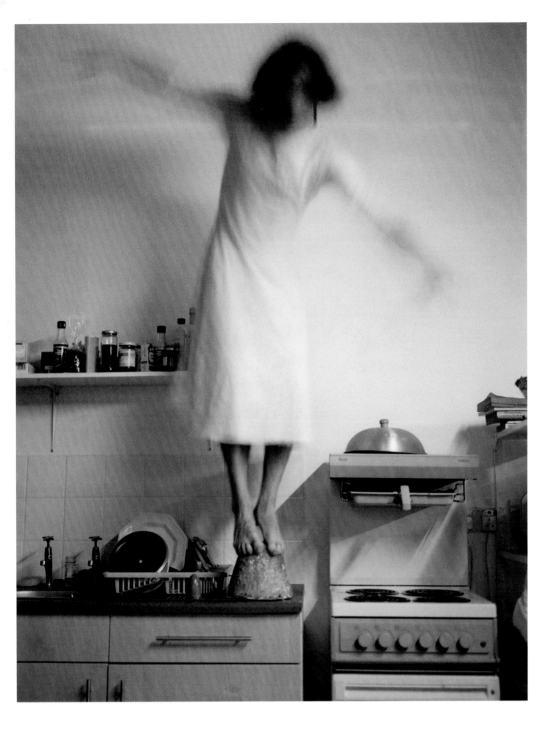

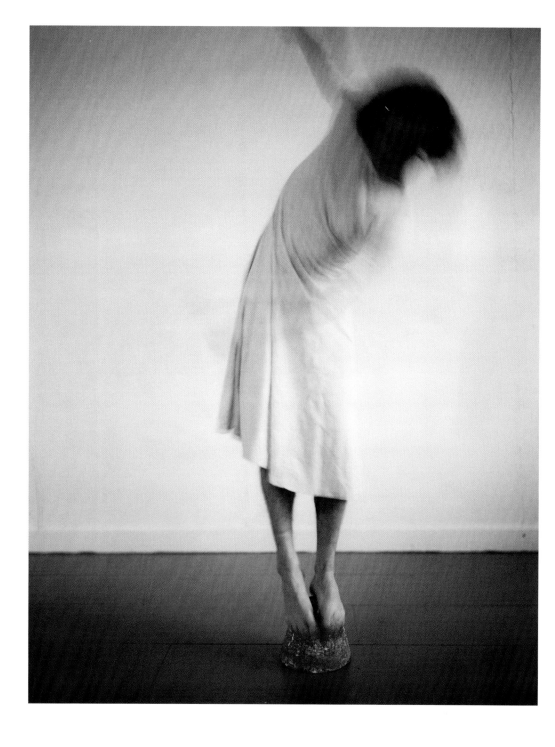

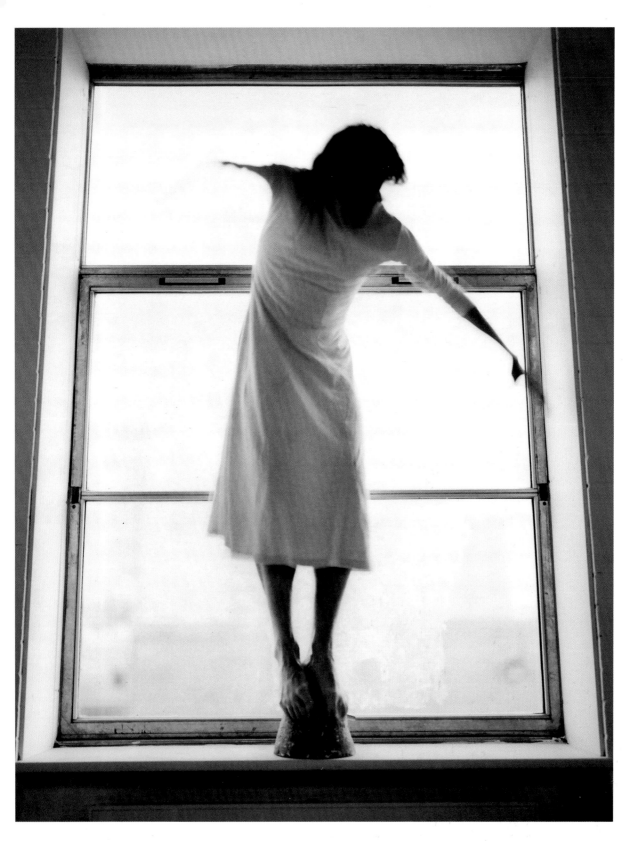

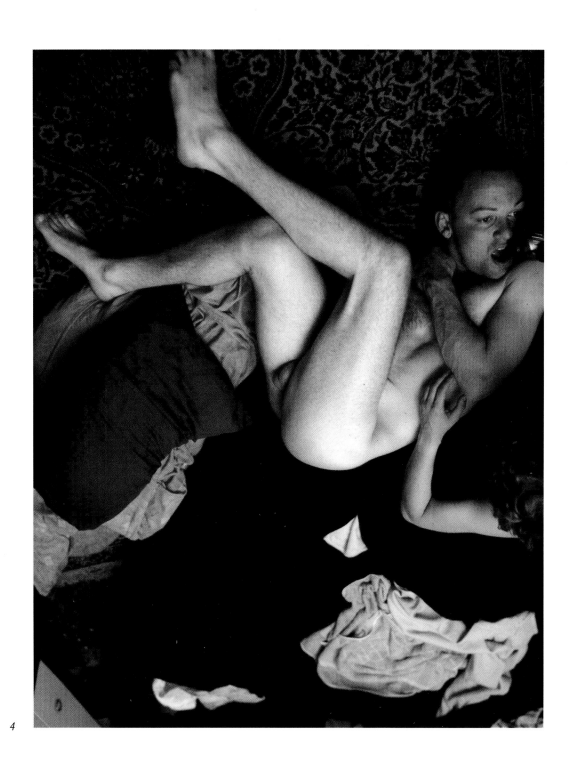

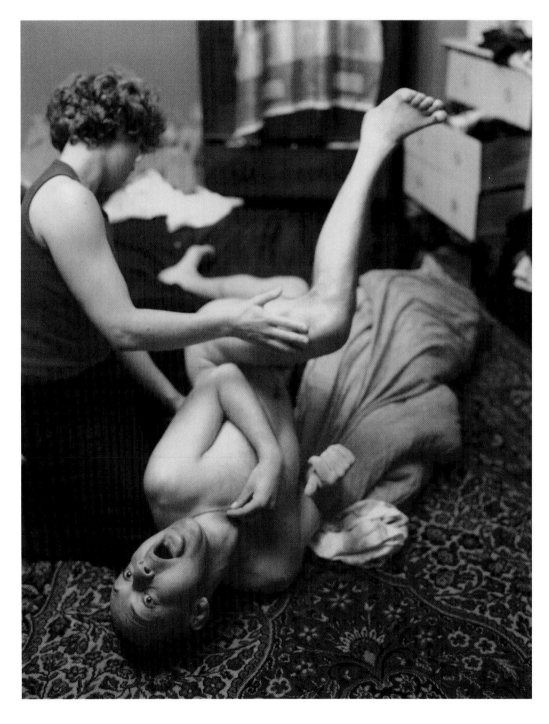

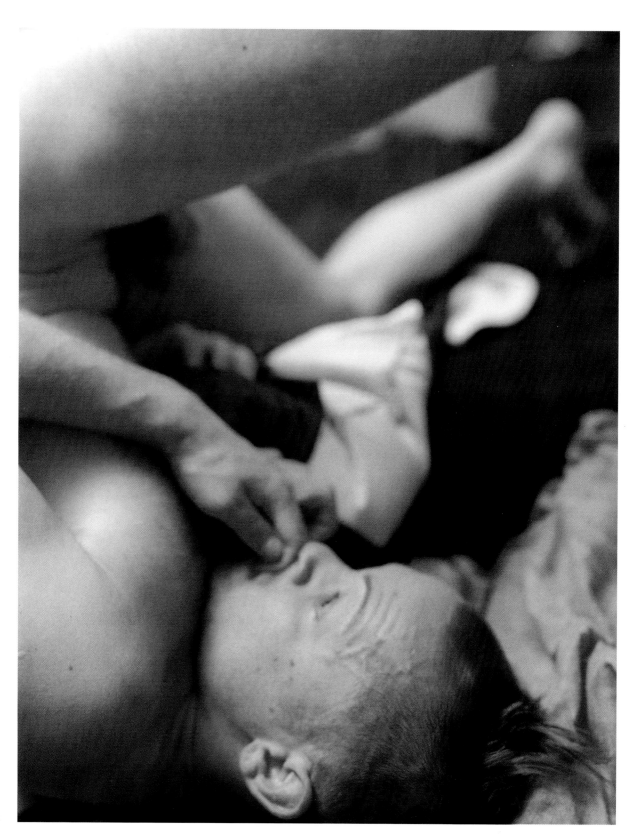

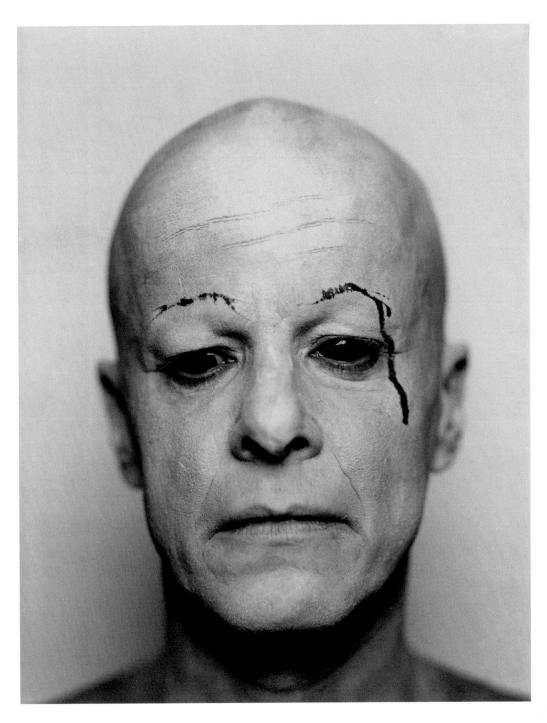

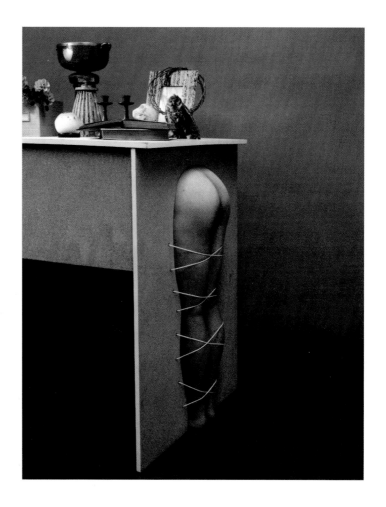

8

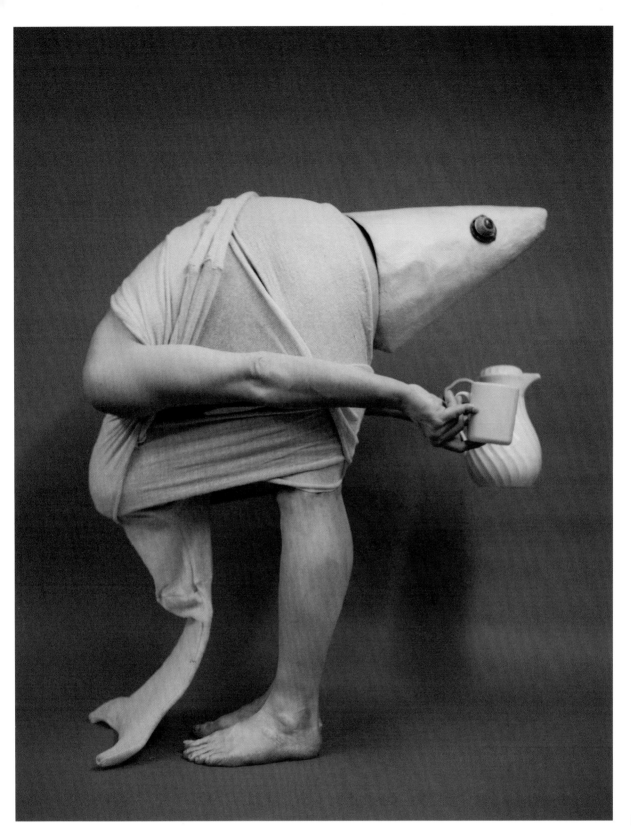

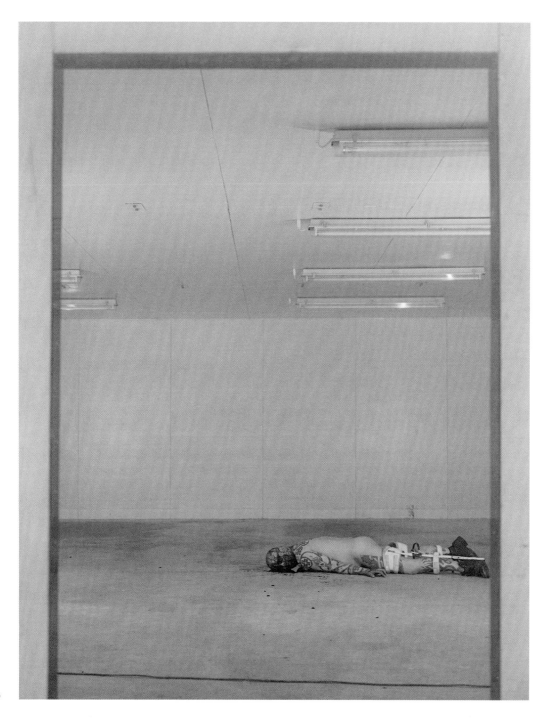

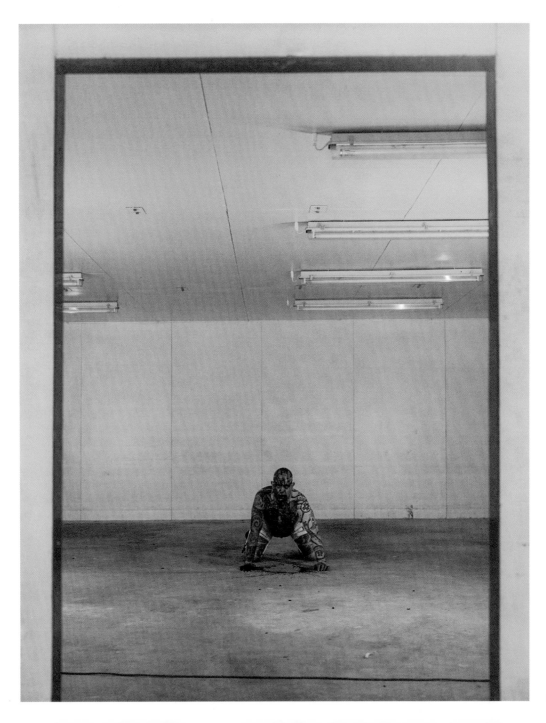

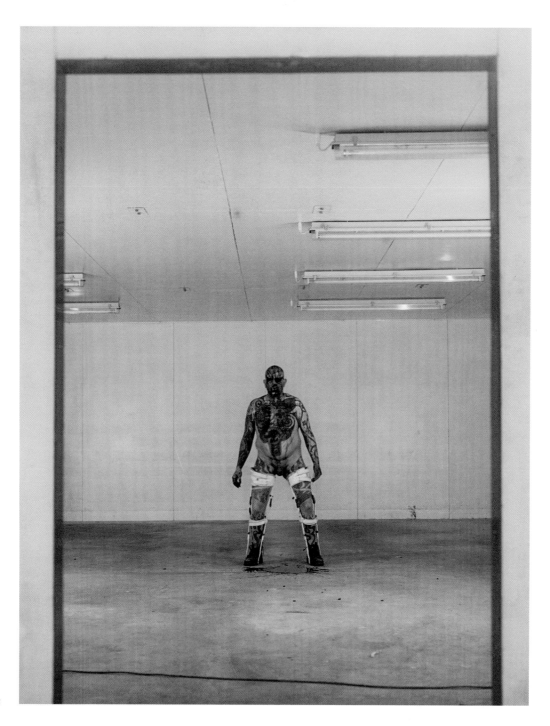

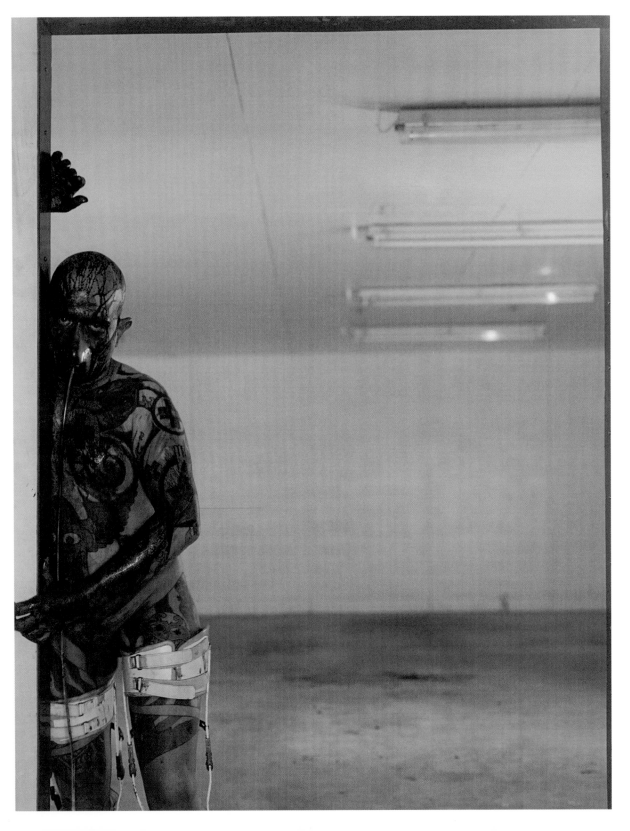

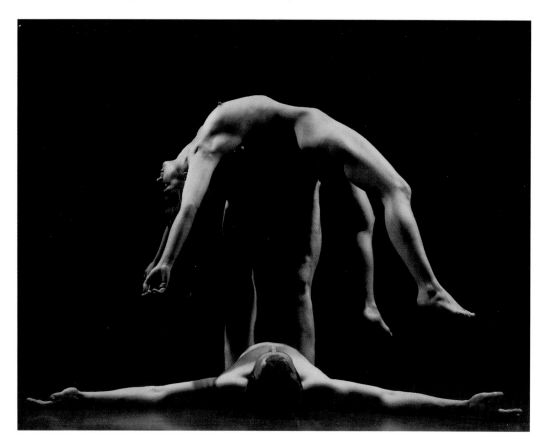

14

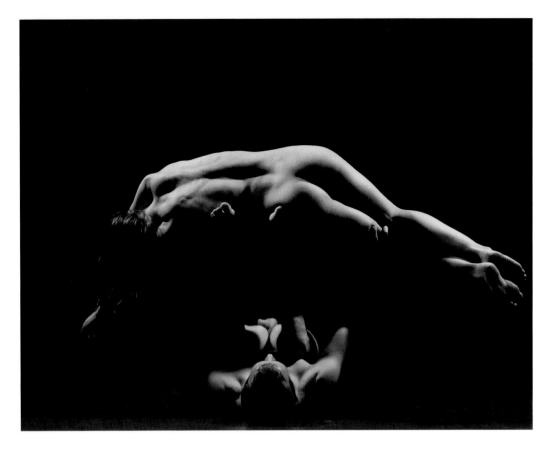

15

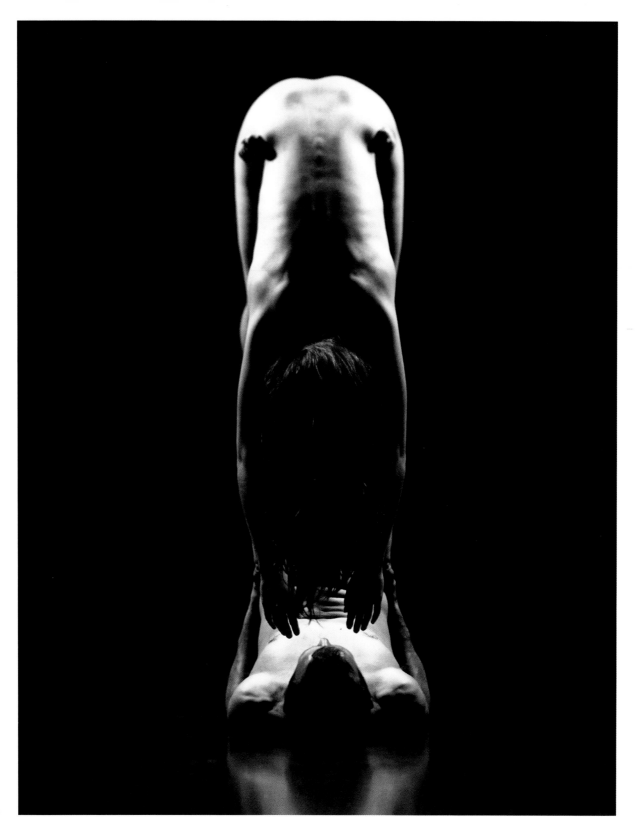

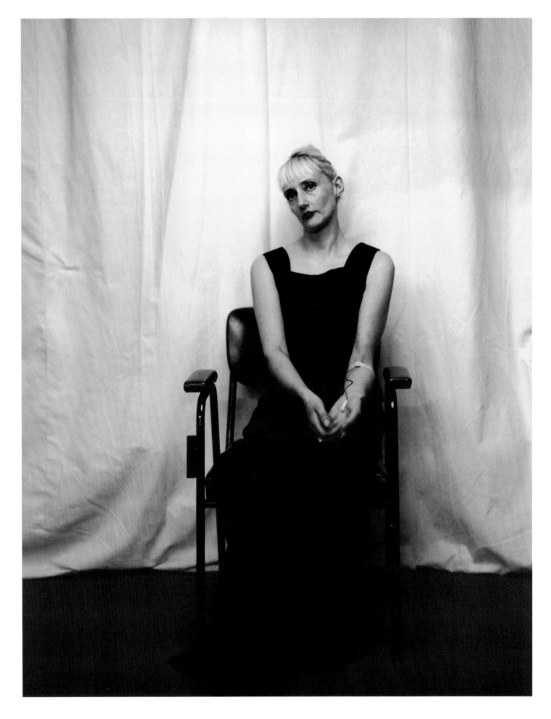

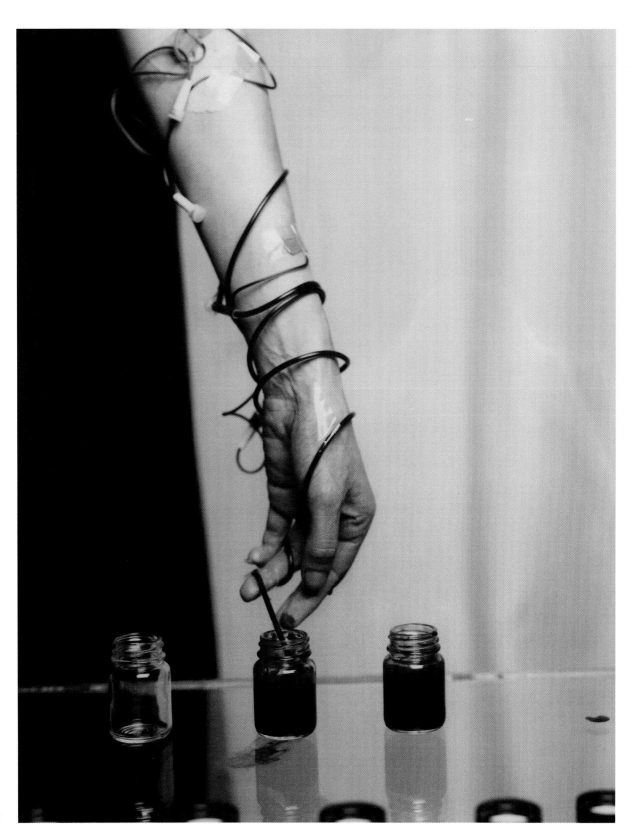

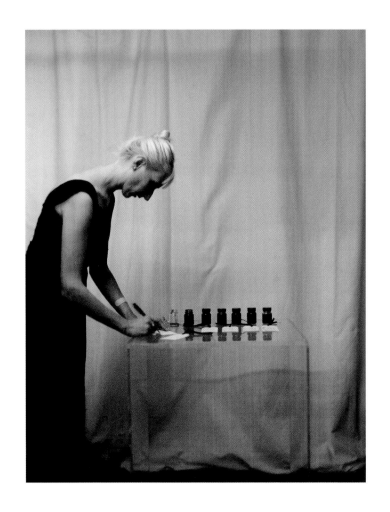

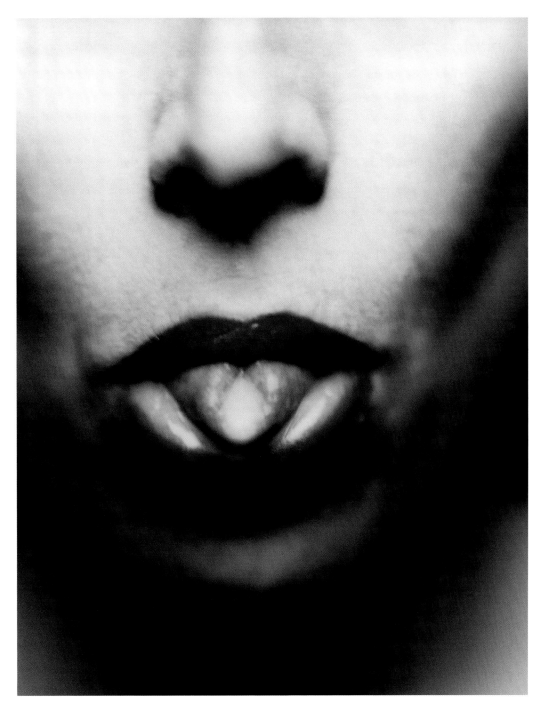

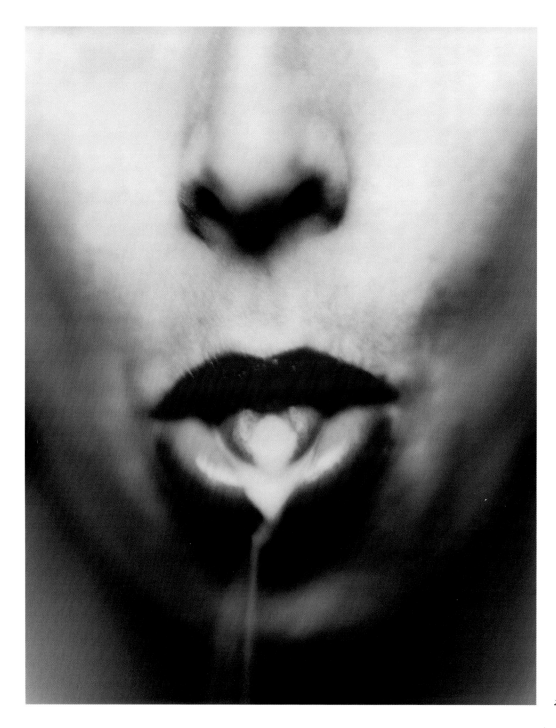

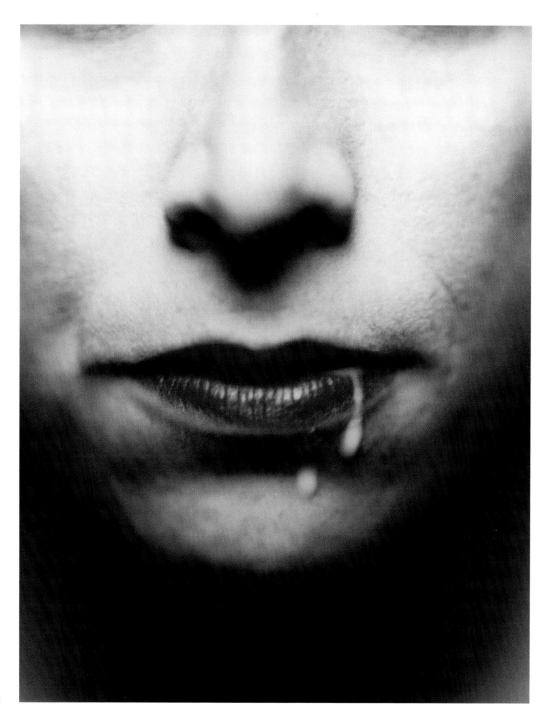

24

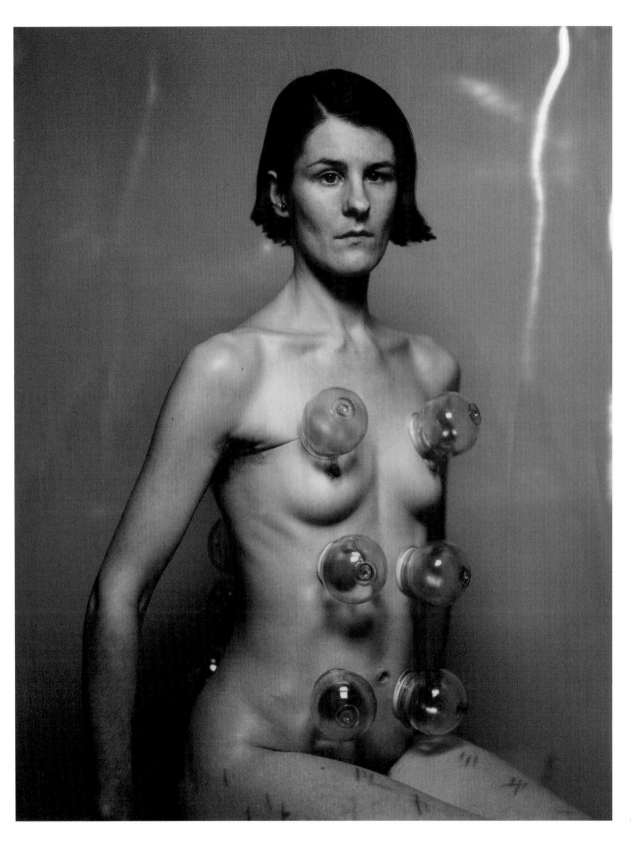

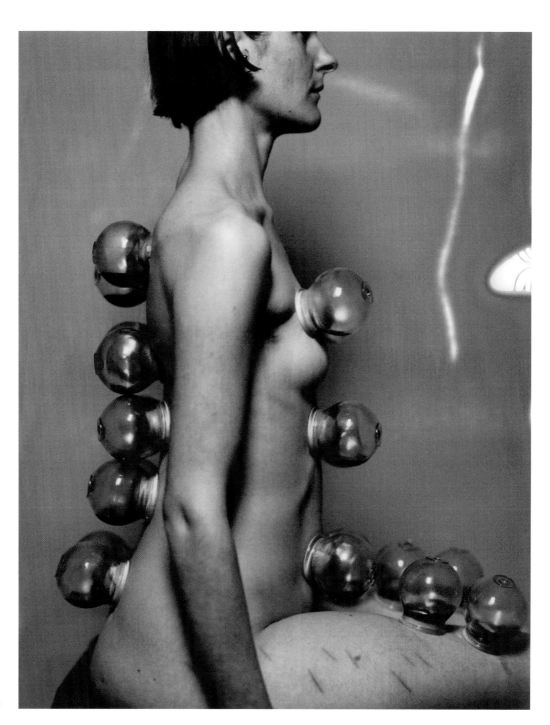

26

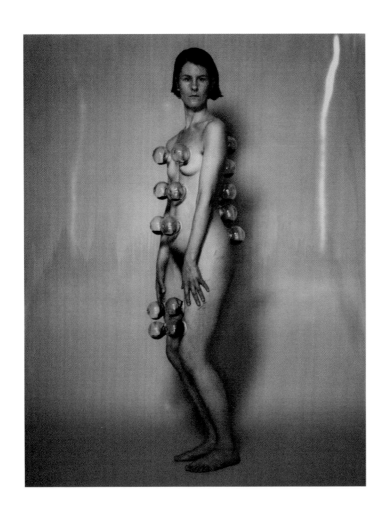

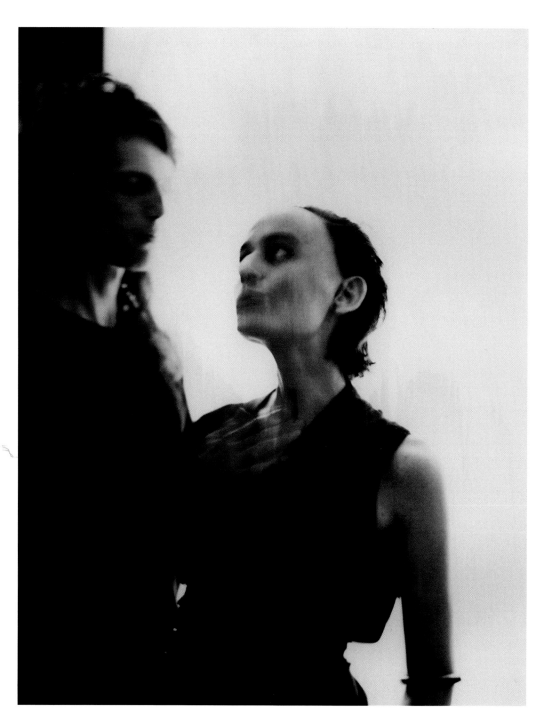

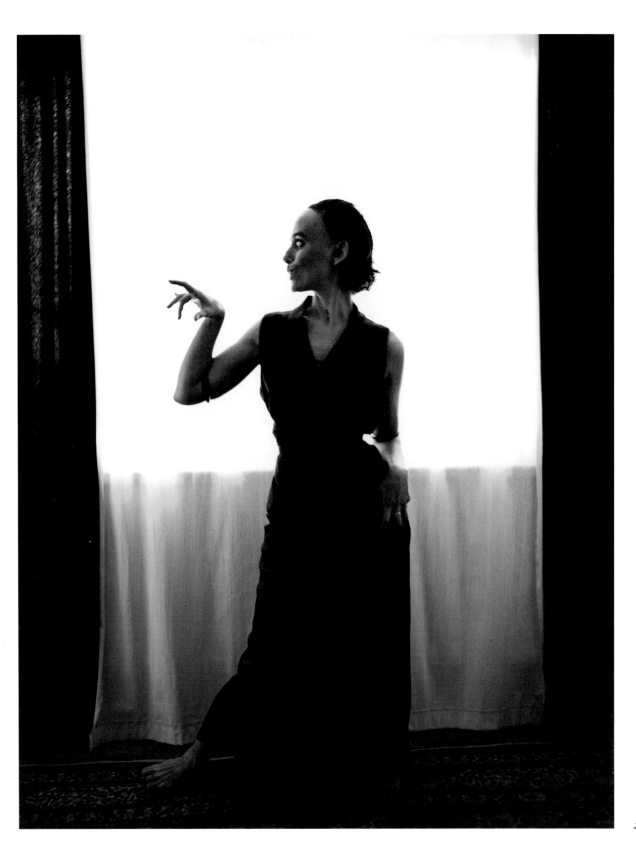

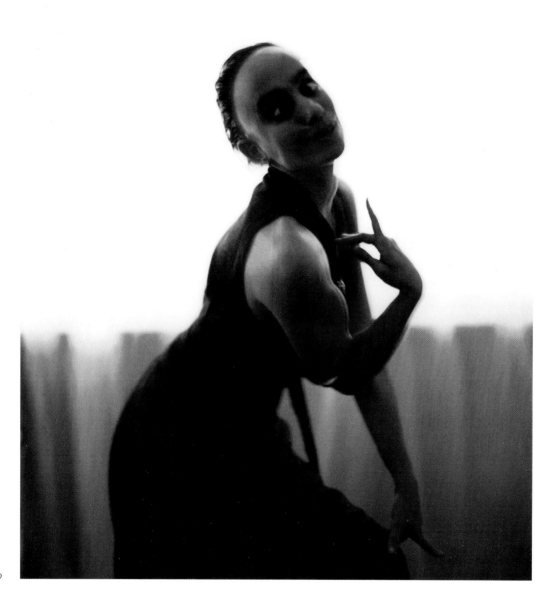

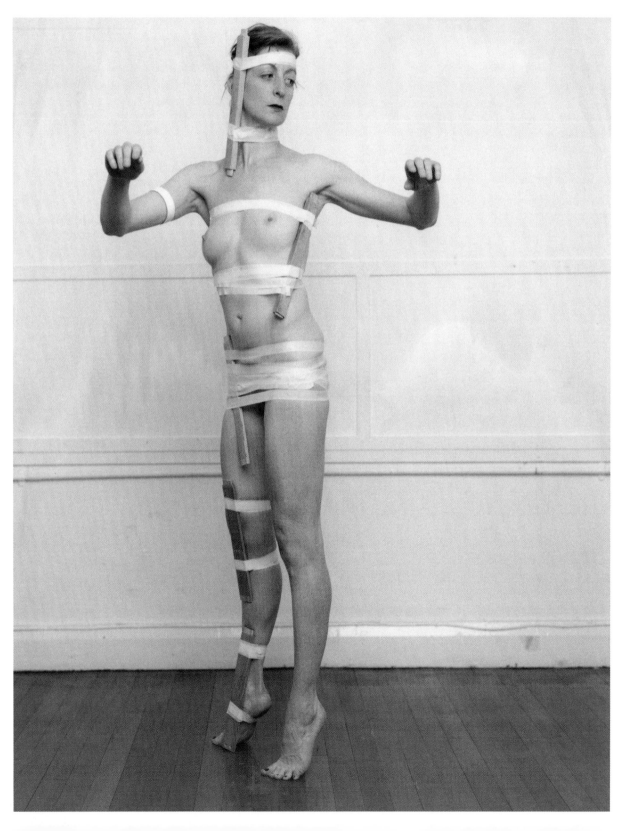

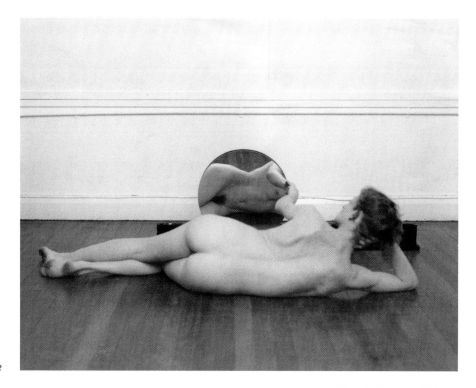

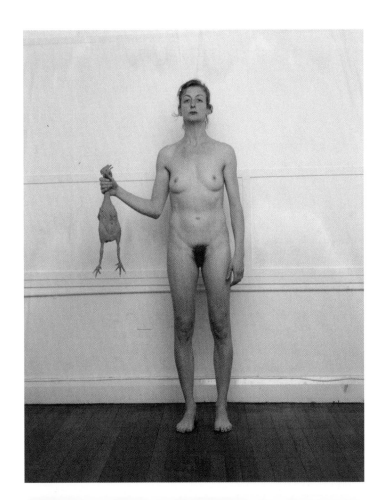

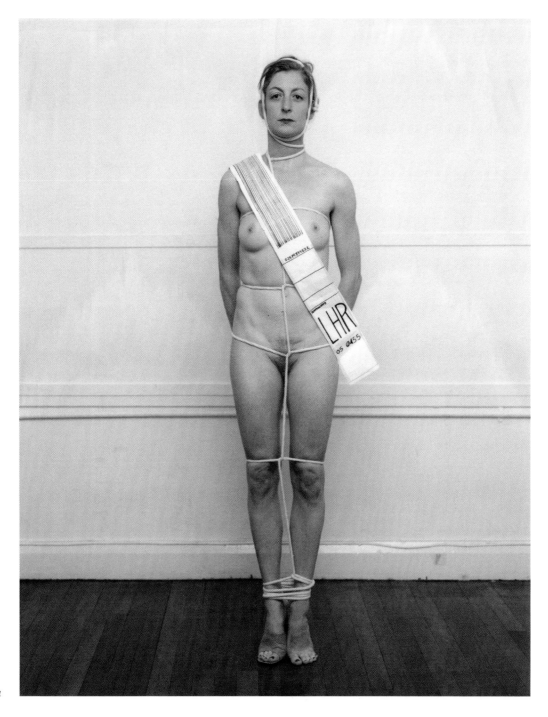

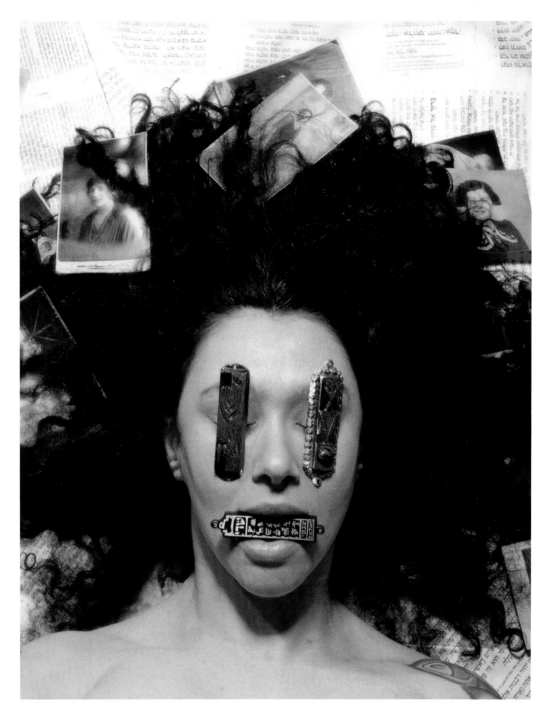

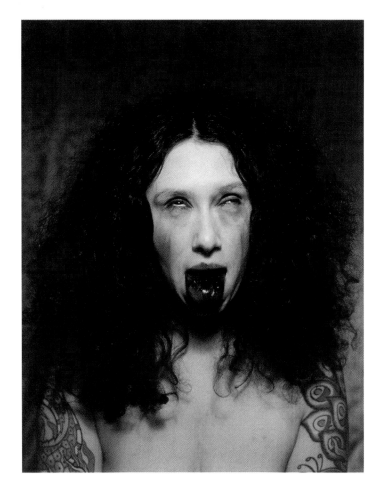

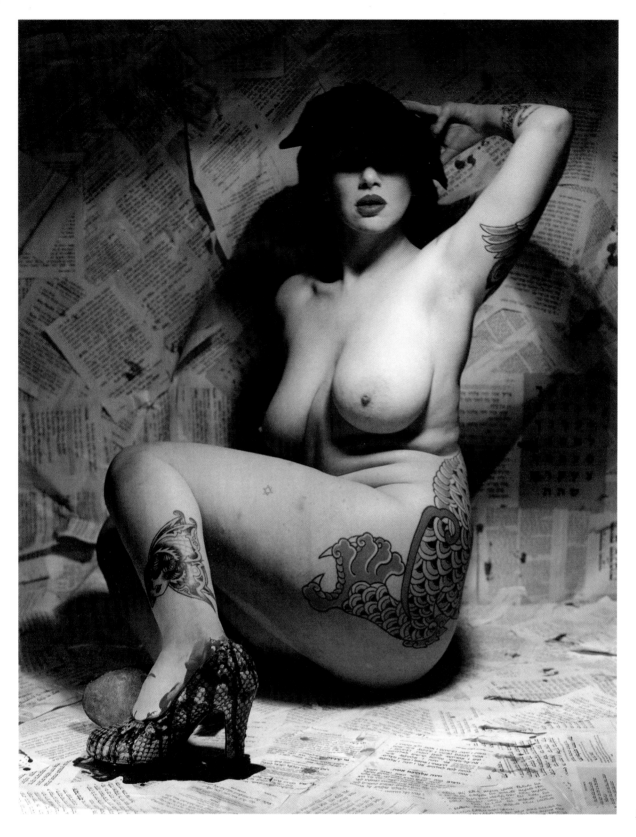

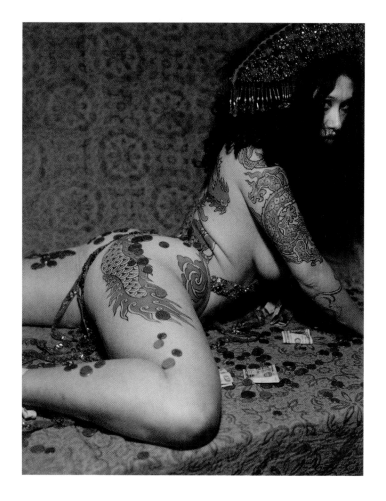

38

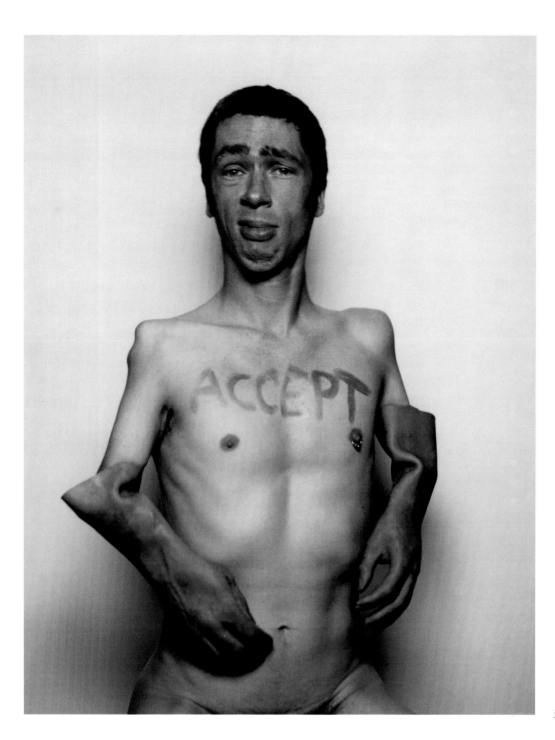

39

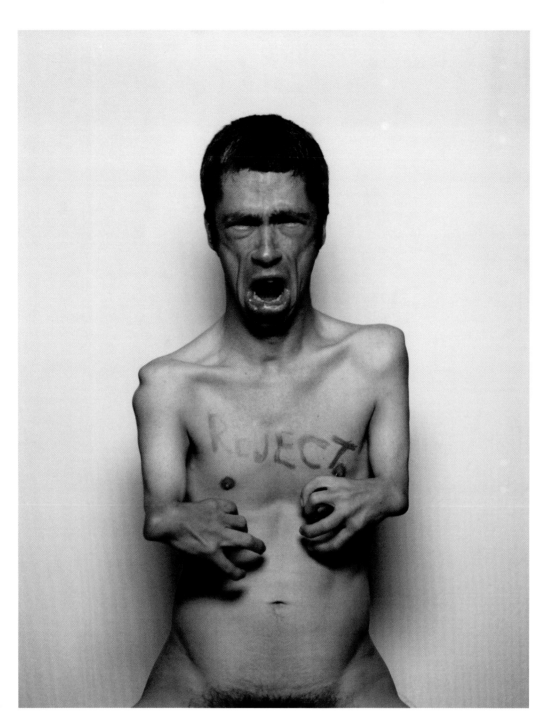

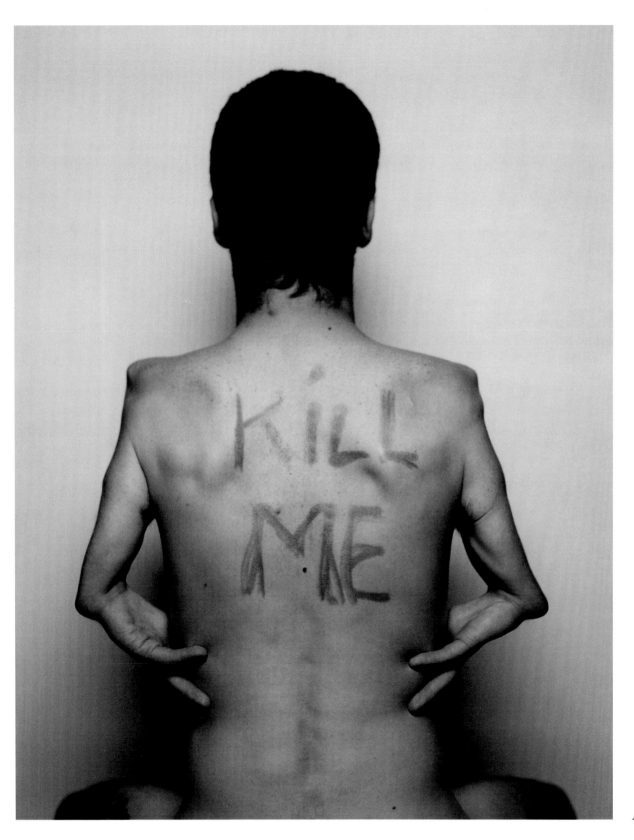

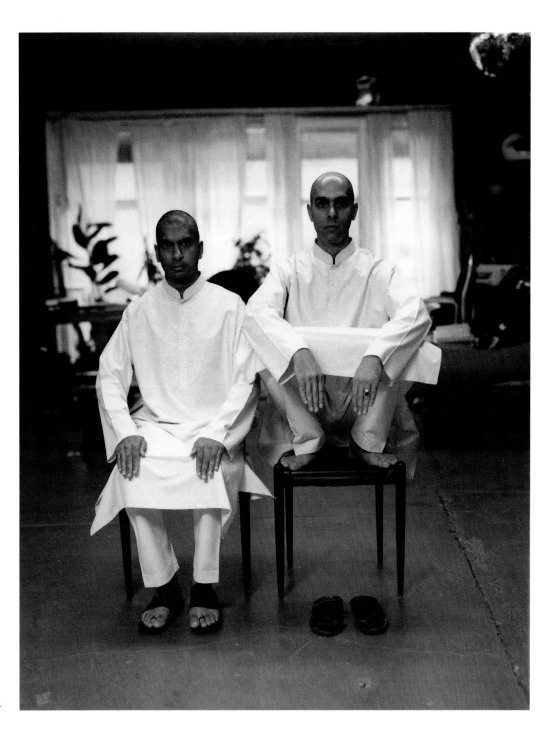

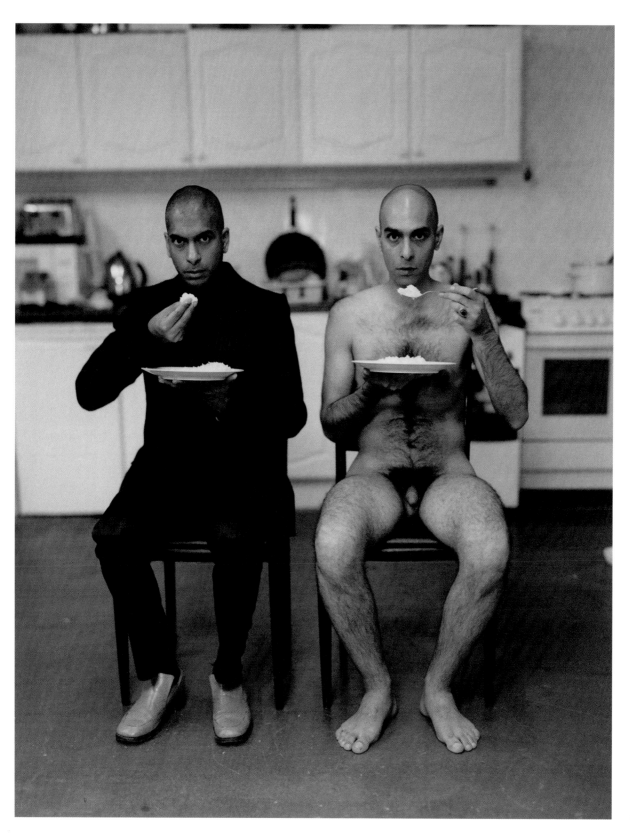

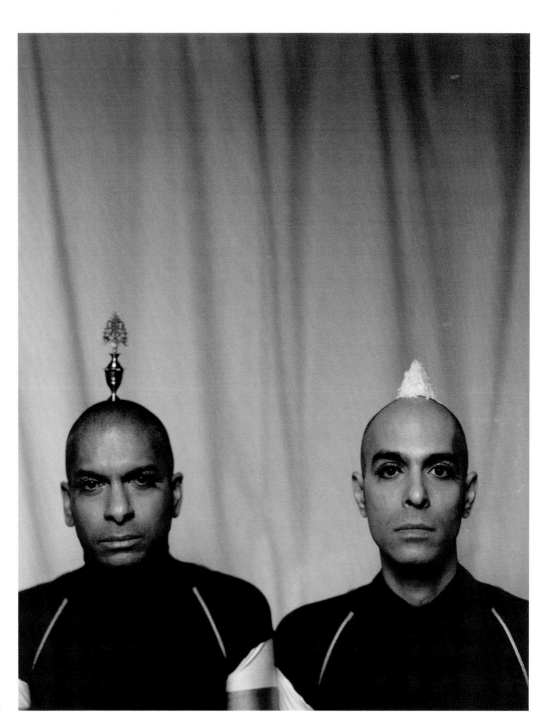

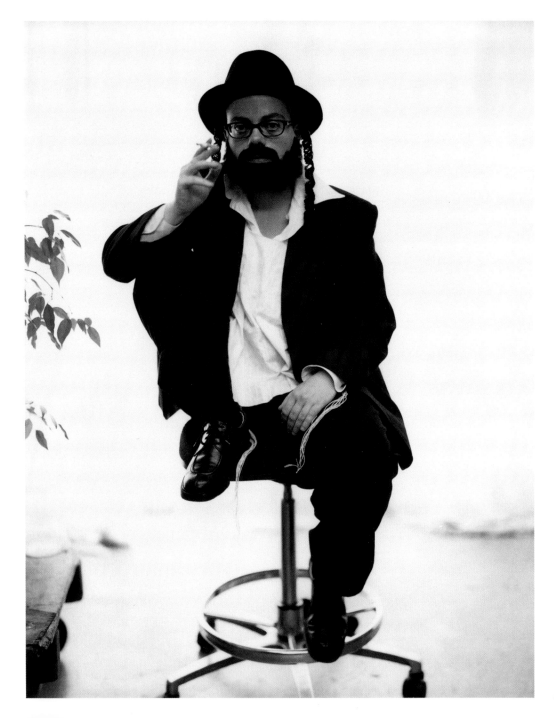

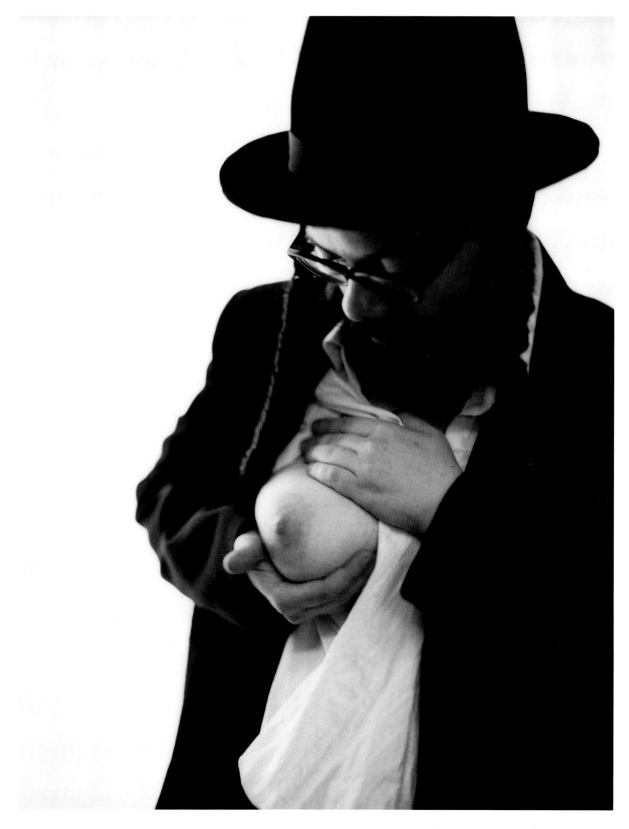

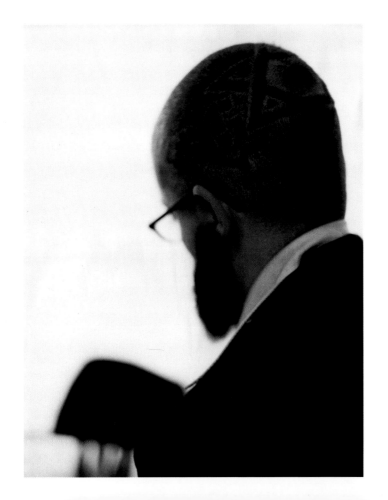

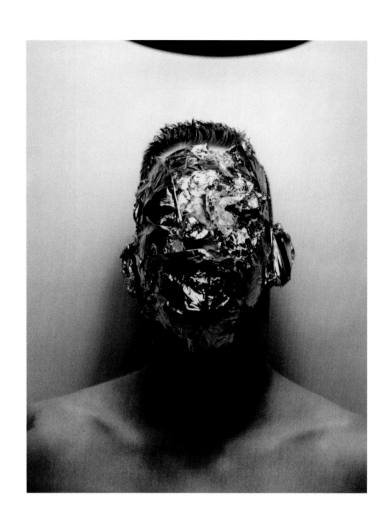

48

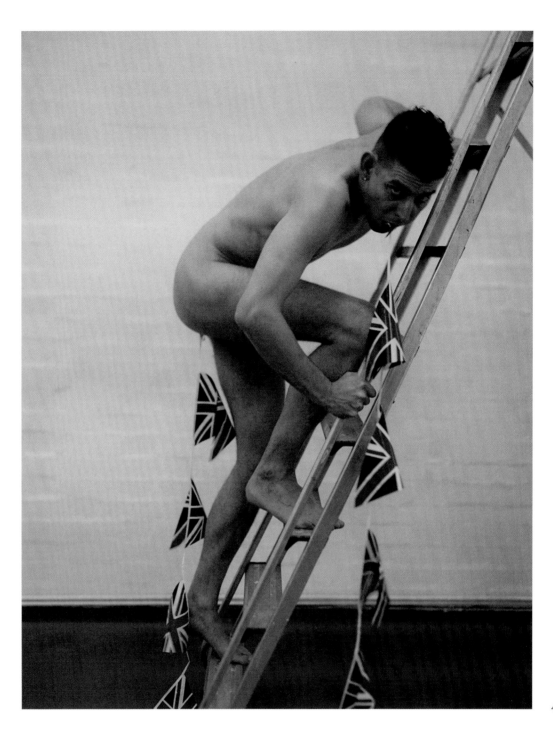

49

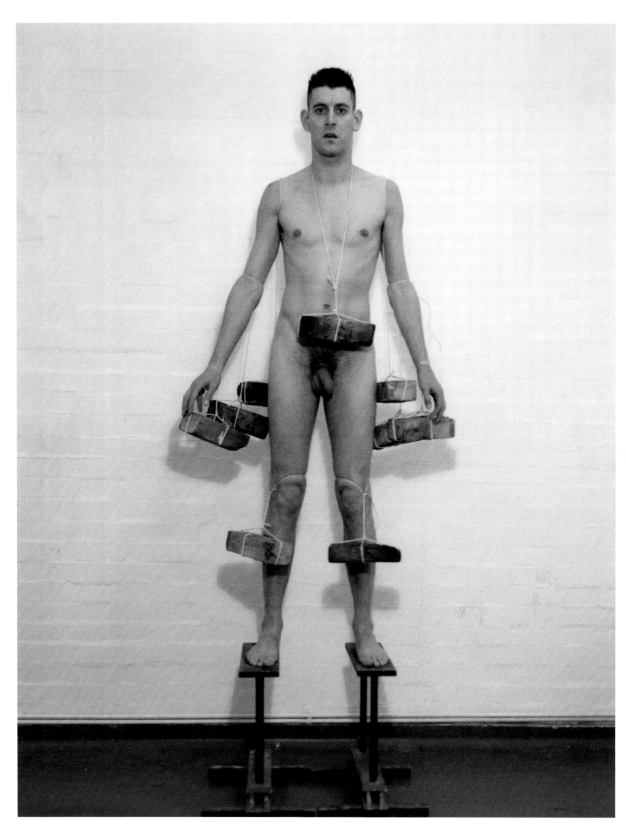

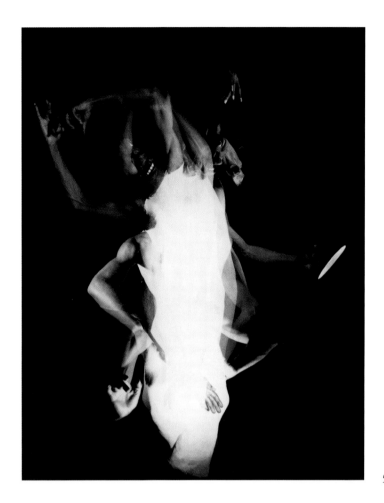

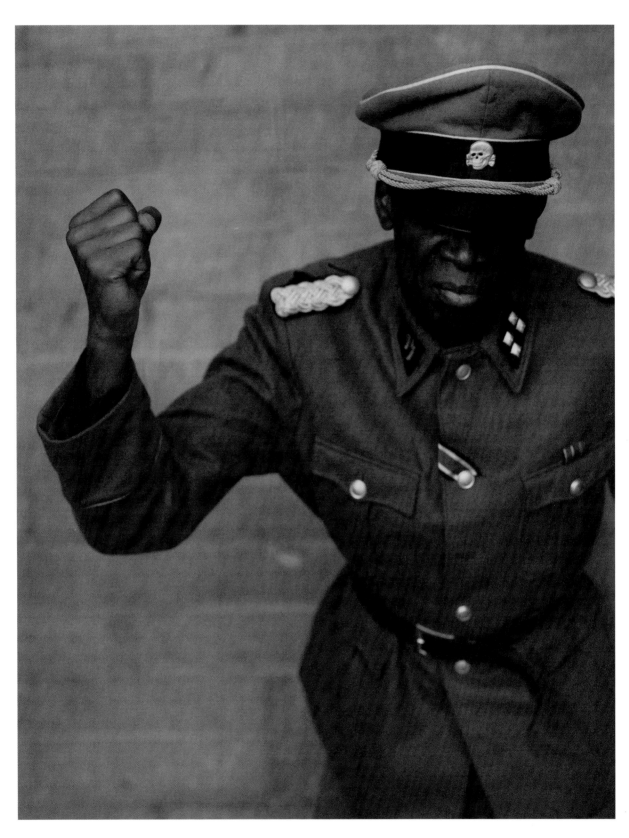

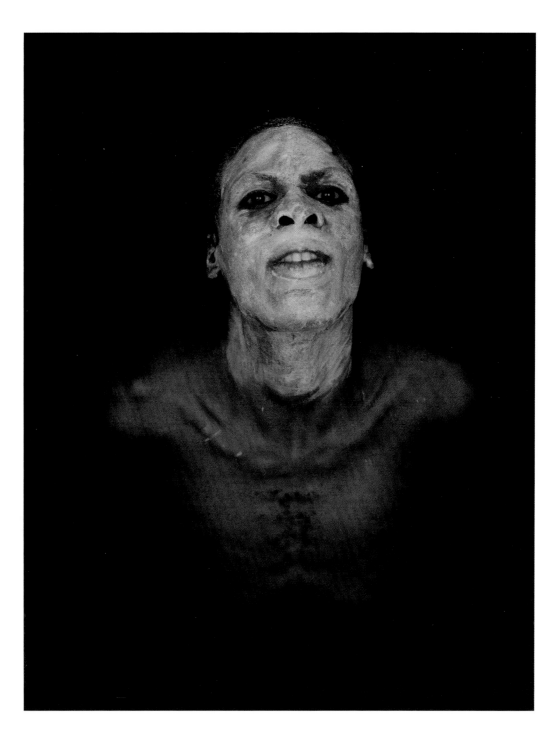

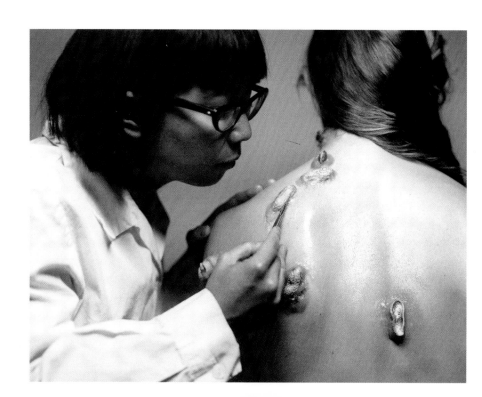

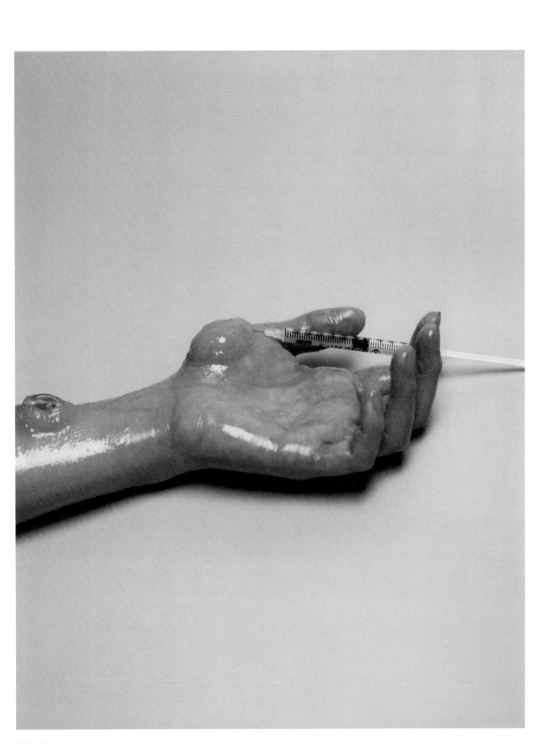

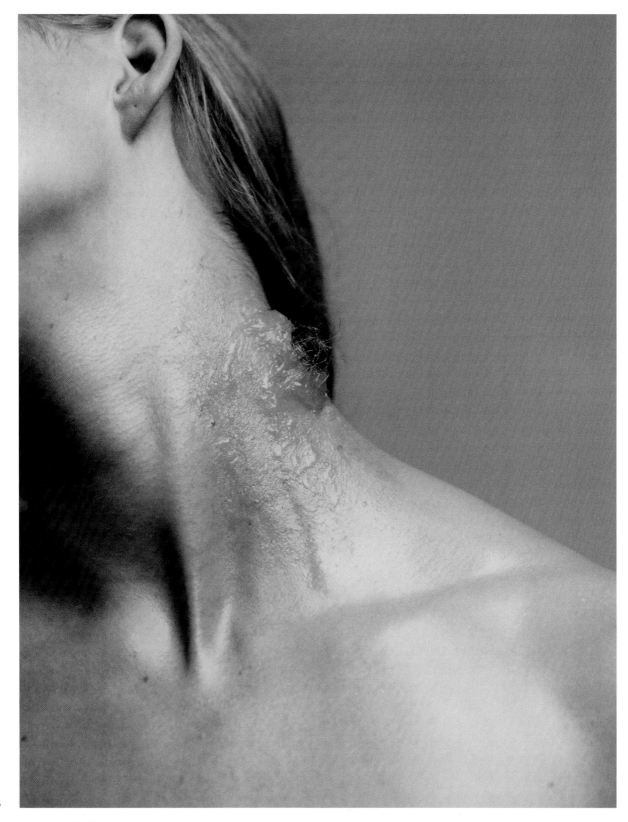

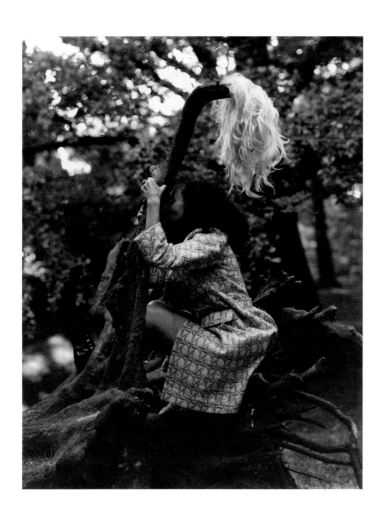

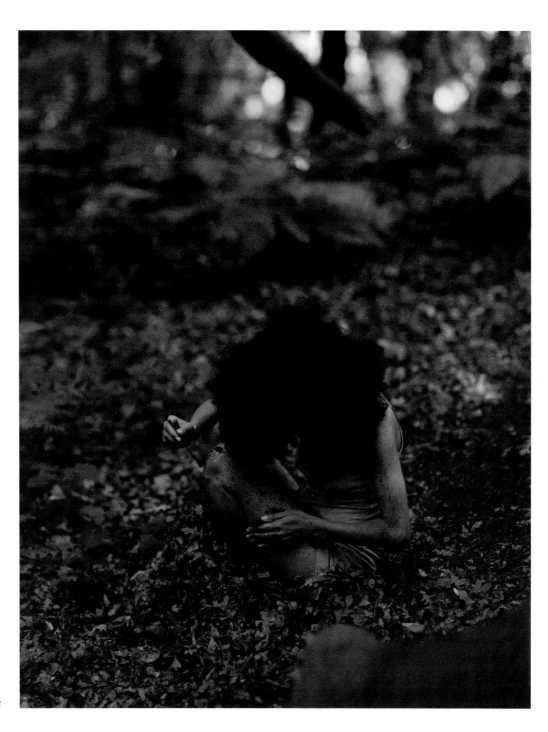

58

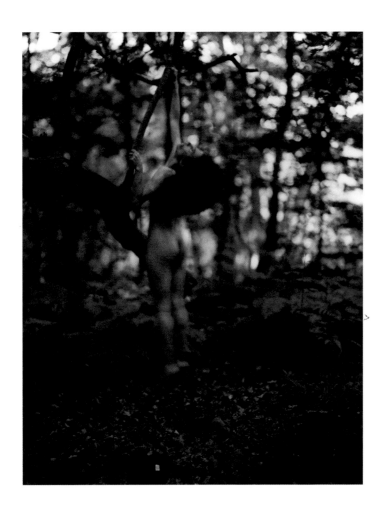

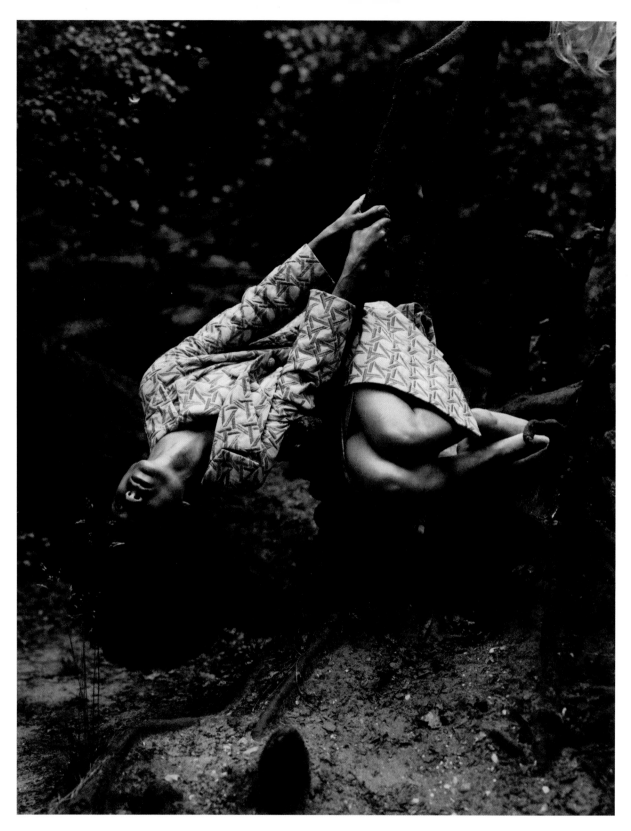

artists' statements

Aaron Williamson

The navel-stone, an omphalos, gravitates to the centre of the space it is placed down in. Simply a foot-high rounded stump of concrete, it can be moved heavily, but the central axis of the space it is in must shift with it. Thus, its gravitational force is not limited to its weight but is also restrained by a perception of intersecting lines. The main use it has is for mounting and wobbling atop. In this employ, it structures balance, its own sense of centre translating into a vertiginous platform once the feet are on. Here, a body sways and shifts involuntarily. At crisis points, rather than fall off, the arms flap about uncontrollably. One means by which the stone navel regains its own centring fixity is by tossing and bucking the flesh navel that teeters above it.

My engagement with performance, objects, language and space is entirely transformed through the experience of becoming profoundly deaf over the course of some twenty years. Informed by this radical personal alteration, my art practice finds co-ordinates within an interdisciplinary approach to the arts that allows an emphasis on disability rather than valorising ability in the traditional disciplinary/craft sense. Hence projects for making art remain open to disciplinary innovation and invention according to circumstance and I have explored working with performance, installation, video, sculpture, text, photography, choreography and digital art often combining elements within one work.

Doran George

26 August 2001
Hi Mum. I've been asked to write something to accompany photographs in a book so I'm addressing the text to you. In a version of my biography that you originally wrote for this book, you said: "The first time I saw Duncan (Doran) on stage, he... was... in the Scouts Gang Show. His Pearly Queen... took the theatre by storm. I was completely amazed, delighted and swollen with pride... however, ever so slightly uneasy that he seemed so at home in women's clothes." When reading this I am reminded of the body that needed to be looked at to live: me. When looking at the photo's I collaborated on for this book I see a body that can't live with being looked at: me.

Somewhere, the separation between on and off stage collapsed. *Auditorium:* Anonymous faces, hidden by the glare of the lights and the invitation to gorge, unseen, on whatever spectacle is offered.
Rest of life: Faces that stare, comment, interrogate, harass, invited to do so by a commodity culture that reduces the body to appearance value and rests on the unquestionable privilege of the consumer.
I've learned that appearing as a transvestite off stage is not highly valued. Attempts to invest images of transgender with value seem to be tied to the narrow and familiar definitions of beauty and gender that underpin this culture of appearance value. "Individual choices" of appearance lose meaning then. Is it possible to embody that loss of meaning? For the photo shoot, I asked Kathy Crick (the woman in the pictures) to arrive at my flat before I awoke and take responsibility for my social functioning. While I thrashed about on my bed, a result of inhibiting my decision making, Manuel, the photographer, arrived, photographed and left. I experienced my body run wild in the closest state I could find to "socially unmediated".

The photos are something else. I imagine the reader, anonymous, as they flick through the book 'consuming' those

seductive images. Perhaps another version of appearance value, and this text struggles with that. In the biography you wrote: "... when I saw Fucking My Purity. It was the kind of unintelligible production that I would have expected from an avant-garde, someone unconnected to me... I sat in the audience, feeling out of place, marvelling, applauding and wondering what on earth." You sound implicated in that show by your particular relationship to me which your text reveals but was hidden in the performance because as "generic audience" you are positioned as anonymous. Anonymity legitimises the viewing of me/my body as spectacle/commodity by avoiding the demands of witnessing an intimate relationship. Text written in the third person is designed to position each reader of a book as equally anonymous, so I hope that by making my relationship to you present here, the consuming of the text or images is interfered with by our intimacy and some of the pleasure/discomfort of being implicated in a text is felt by the reader.

Duncan/Doran. X

Ernst Fischer

There was a phase during my adolescence, when I forced my arms and torso into jumpers and cardigans that always seemed at least one size too small. The pressure of the fabric against my skin served as a constant reminder of the beginning and the end of 'me'. I felt contained, complete and somehow 'present' in the embrace of my garments, which provided safe boundaries and prevented the fragmentation and dissipation that I both feared and desired. A few years later, however, I resented a lover's attempts to dress me in tight T-shirts and pullovers that cut into my flesh, restricting my movements, circulation and breathing, yet far from affording me sanctuary, left me feeling exposed, objectified and categorised in the eyes of others. What I am trying to illuminate with this brief juxtaposition, is the tension between agoraphobia and claustrophobia, of secrecy and public disclosure, which

fundamentally motivates my work. In truth, I hardly know if I am coming or going, if I am trying to find or to lose myself, or whether there is ultimately much of a distinction to be made between the one and the other.

Agoraphobia and claustrophobia have been described as symptoms of the architectural Uncanny, a malaise that was first recognised in the metropolises of nineteenth century Europe, and still infects the postmodern citizen of fragmented and alien urban environments with its particular brand of melancholia. As a gay man with a troubled relationship to the nuclear family and its (gendered and gendering) values and as a foreigner and immigrant in an unfamiliar city, I began to perform my homesickness by staging camp theatricals in the living room of my rented flat in Brixton, South London. Friends and neighbours became my collaborators, and for a moment or so we managed indeed to create a fleeting sense of community around and in our shared work and living space. Our aim was to invent large gestures and scenarios in resistance to the architectural and ideological restrictions of a modest domestic dwelling. The flat was redecorated to house each new production, and for some ten years, its interior was caught in a continuous process of transformation. Since the demise of this living room theatre practice and my subsequent exile as a performer, my work has focused much more consistently on the un/homeliness of physical restrictions. While I thought of my living room theatre as architectural drag (house-coats for the home-o-sexual), I now struggle to stage the metamorphosis and dis/appearance of the body in the privacy and interiority afforded by bandages, blindfolds, fetishist footwear and domestic furniture.

The privileged sites for the metamorphosis of habitat and inhabitant in my work are the anus (the 'grave' of masculinity) and the closet: literally the space of writing in the Renaissance house (the forerunner of the studio and the office), but also a container for disguises, and the territory of the abject and of queer identities. This conflation of body and house resonates

strongly with the other major interest in, and influence on, my performances, namely Butoh, whose founder, Hijikata Tatsumi, often spoke of being inhabited and moved by the spirits of the dead.

Franko B

My work presents the body in its most carnal, existential and essential state, confronting the essence of the human condition in an objectified, vulnerable and seductively powerful form. I believe in beauty, but in a beauty that is not detached from life. My concern is to make the unbearable bearable; to provoke the viewer to reconsider their own understandings of beauty and of suffering — usually we try to avoid such situations in life and cannot face being confronted with our wounds.

My performance practice reduces the body to a carnal, bloody, raw and exposed state. My work is not about death; my body is not passive, not a dead body, and, in a way, its giving life by bleeding. My work is not an act of nihilism but of survival. My work focuses on the visceral, where the body is a canvas and an unmediated site of representation for the sacred, the beautiful, the untouchable, the unspeakable, the ignorant and for the pain, the love, the hate, the loss, the power and the fears of the human condition. But I'm not trying to express what I care about in a cognitive sense — all I can do is return to this fragile connection between real life and the experience of living.

I believe Live Art is something you feel in the action and the reaction. But I don't separate my Live Art work from my other, object-based work or vice versa. All of my art embodies 'me', and my body is always present in my work whether the form is a live event, a photograph or an object. You can read my performances as sculptural — I am painting with my blood.

Gilles Jobin

My work deals with issues of the body: what is flesh, what is body; the complexity of the human mind and its relationship with the body; the body as a living art object. I believe in a thinking body, that flesh has memory. In the piece A+B=X, I was working on suggestiveness, using forms and shapes that would relate to the spectator's personal experience, trying to get through the different layers of memories. It was up to the viewer to look into his own self in order to give the images their true significance. Almost constantly putting the body upside down I was confusing its normal perception by putting it in a different dimension, isolating it in space. Using slow dynamic motions and continuous movement I was stretching time to its very limit, confusing the perception of time. In Braindance, obsessed by death, I was manipulating the body, searching for the limits of what a body can do to another body, what a body is ready to accept when manipulation becomes vital to survival. In the duo piece Macrocosm, I was exploring three distinctive visions of a body: the representation that the mind makes of its own body (the dancer), the professional non-emotional care of that body (the manipulator), and the vision of it all (the spectators) that were, by their presence, put in an active role and could project themselves into the different perceptions of that body.

My work is now evolving to a more dynamic motion (The Moebius Strip). If I continue to use the suggestiveness of the body in terms of the mental images that it provokes, I have lifted the perspective of my work into a higher layer of perceptions. I have placed the body into a more existentialist perception, more abstract, using space in an auto-organised geometrical grid. Movement is self-organised and the dancers must make constant choices to choose their positions in the space. The work is now furiously organic. Musical score plays a major role in all my work and all the music for my pieces has been composed by Swiss musician Franz Treichler of the The Young Gods — the music is essential in participating in the spectator journey.

Giovanna Maria Casetta

Using the body as a site I am concerned with exploring identity, both fabricated and real, by addressing the surface and what lies beneath. Integral to these explorations is how the identity of the individual can be misread or misinterpreted.

The Blood-Lettings is a series of performances that are a conscious act of "going into the body" to reveal the hidden; the true identity of the individual from which there is no escape, no disguising or changing. The Blood-Letting 5 — Encapsulation deals with society's reading of identity through the outward appearance of a body, a body that can be tailor-made to that which is most desired through clothing, cosmetics, exercise, diet or even surgery. However, what is under the skin cannot be altered and will betray one's true self.

I would describe this series of work as being my most honest, rawest and revealing: an opening of the self. It is work that can not be hidden behind and that is constantly raising issues and asking questions of me. I have to admit, therefore, to having been apprehensive about having this piece photographed by someone who was unknown to me and unfamiliar with my practice, particularly as a female artist working with the body in this way.

Before beginning the shoot Manuel and I talked extensively about what my work was about and what we wanted to achieve from this experience. I felt it was very much a collaborative process, and, the results were astounding — the images have captured an essence of the work which is often missing in its documentation.

Looking at the images each picture reveals a different aspect of the work and captures the tension between the glamorous and visceral. In one image I look like a doll, or a mannequin, but there is an underlying defiance in the direct gaze to camera which says "I have consented, I am in control. You look but you see me as I wish to be seen."

Helena Goldwater

imago

The focus in these photos on the mouth emphasise the detail of my concerns. Sexualness and sexuality. The image could be male or female, the fluid bodily or external. Manuel and I shot these images and the sequence revealed itself. They became performances in themselves, unique to this book, to Manuel and I. The innuendo of a wet mouth. How neglected and taken for granted is the importance of detail.

persisting in the unconscious as an influence

In the everyday we reinvent the familiar. The difference for me in making live work is that the reinvention is dwelled upon, a transformation explored. Objects and the body take on new and greater meaning. These are not taken for granted. In a world of constant sexualisation, the eroticisation of the everyday for me takes on a spirituality. The strange language of double entendre mixed with a kind of poetry can say it all. I am preoccupied with the unspoken, and how to speak it; how to communicate those moments that are inexplicable. For example, how do you talk about spirituality, sexuality, identity, without categorising yourself, without resorting to cliché? How do you transcend language to say what you really mean?

Joshua Sofaer

It is about 8.00am when Manuel comes to pick me up in his van. I lift up the boxes of costumes, load them in to the back next to his photographic equipment and we head off for Oxford Street. We had briefly discussed what the intentions of the photographs might be, but by no means did we determine an exact plan of action.

The bare-buttocked suit has been used for two different pieces, both of them performative lectures. The first, Concepts and Conceptions: A bare-buttocked lecture was a site, audience and

event specific piece created for the ICA's 50th birthday celebrations, where the suit acted as a wry take on the supposed transgressive aspect of the ICA's curatorial policy. The second piece, Embarrassment: A bare buttocked lecture has been performed in various sites including galleries, theatres and lecture halls in different countries. My aim in the performance is to try and become embarrassed live in front of the audience and the suit conspires to help me in that aim.

On the capital's busiest shopping street, people are amused. They point and laugh. It becomes clear that the humour arises not so much from the fact that they can see my bottom, but that it peeks out of what is otherwise a traditional, conservative, well-pressed business suit. It is the juxtaposition of the fabric with the flesh that makes it funny.

While this 'costume' was created for specific performances, here it has become a photographic performance in its own right, where the relationship between the two 'bare-buttocked' photographs makes the event.

The way in which these photographs perform is of particular relevance to my arts practice which is concerned with the relationship between the 'event' and the 'archive', between the temporal and its representation. Emanating from these discussions where the recording of live practice becomes crucial, are a series of questions relating to what exactly constitutes performance itself. This has given rise to the creation of live art events, writings and discussions which seek to interrogate the relationship between a recording and its creation, between performance and its documentation, between the repeatable temporality of the recorded moving image and the ephemeral temporality of Live Art.

Working on a project by project basis, often to commission, I have been determined that the work should issue from a critical practice that nevertheless employs humour as a fundamental communicative strategy. My body has often been at the centre of this practice.

Often trying to manoeuvre myself into the position that I seek to explore in the work, or taking advantage of those occurring through happenstance, I have worked as a pornographic model, trained and competed as a powerlifter, undergone major surgery to my skull, have spent a month pampered by a course of beauty treatments, and have given over my home for an interior design transformation. These photographs became another site for work; not reflecting or promoting some other piece but performative photographs themselves.

Kira O'Reilly

I approach the body as a site in which threads of the personal, sexual, social and political knot and unknot in shifting permutations. The materiality or fabric of the body, as well as its specificity, is seen as something that can be explicitly intervened with. The relationship between bodily interior and exterior spaces are considered as a continuum, the permeability of the boundaries of the skin defying it as an impenetrable container of a coherent or fixed 'self'.

The work simultaneously recognises and resists the signification of the (specifically female) body and investigates the dynamics of looking, the audience become complicit in this by undertaking their own process of confirmation and denial around what they are seeing. A sense of intimacy is established. A contract of sorts.

In recent works I have used old medical blood letting techniques on myself as a bodily articulation, invoking notions of trauma (a wound) and stigma (a mark) towards a 'spoiling' and opening of the body suggesting an alterity or otherness.

I use a procedure called wet cupping where round glass 'cups' are heated creating a vacuum so that they 'suck' onto the skin.

This suction draws the blood out and into the cups though superficial cuts. I was drawn to the sculptural implications of working with the cups: they become extensions of, and extend my body, by working with the plasticity of the skin.

Historically this work, Wet Cup, had been relegated to the hidden, the secret, in camera (in chambers). The sitting for Manuel Vason for these images continued this in camera. The meaning of the work is continuously informed through these tiny shiftings of context and site which cause the boundaries between public and private to blur again and again. The making of the images resided in an uneasy and ambiguous place somewhere between documenting, performance and fashion shoot.

There is a look, an aesthetic in the images that leaves no room for escape, for myself and perhaps for the viewer as well. There is a harshness and a brutality in the unrelenting detail of the work almost clinically exposed thus.

Throughout the process of this piece, there has been a repeated opening of the skin. The differentiation between 'making' and 'performing' has become confused and redundant as my body has persisted in its own methodology, whether it be before an 'audience', in the studio, in front of Manuel's camera. The slight scars seen in the images testify to this, tracing a history that can be followed on the surface of my body. For me this is a process that defies notions of fixity or finish despite being momentarily arrested within the form and framing of the photographs.

DogonEfff

Thought as matter,
Thought as presence,
Thought as optical image,
Thought as impulsion.
A conformation of light and of vision.
To be a far seer...

One of the first ways we described our artwork was as an interaction between two seeing forces — the force of video and the force of performance. Schematically what this interaction makes is a video image operating in a duration where time draws itself as an optical presence: seeing is a becoming of touch, it is our line of sight, and our reality.

For our photographic session with Manuel Vason, we felt we had to include him in one of our own recordings. In considering that we ourselves make a video image, there seemed little sense to the session if Manuel simply stood to one side and proceeded to make his Polaroids, as though he were invisible. Equally the Polaroids could not be straight portraiture — there had to be an involvement.

The plane of immanence, a plane of desire: is a desire that does not search to be fulfilled — we tried to draw it once — as indivisible motion, as indivisible tendency, as real duration, as real presence.

Duration, as taken from the philosopher Henri Bergson, is essential to the meaning and complexification of our work. Bergsonian duration is a consideration of time where a material presence is a never ending leap of affection and sensation, a movement or an image forming a succession of actualities of our everyday experience. How we record the experience of this presence is through an understanding of the nature of the materials used in the artistic process: a human figure, a digital video camera, the space and light of an everyday living room in London and in this instance Manuel's camera.

When we consider that each of these materials is present, and each material acts as a sensation towards movement, then each material is a becoming and a part of the artistic process. It is how we see the world. In our living room we try to make something extraordinary out of the ordinary. It is a point of being there. For us it is the present as the very matter of existence.

These are not imagined states, or sensations or conceptions or mirrored reflections: we transcend and transverse, things, entities — and thus touch intuition where our optics, our simultaneities, our fluid representations — unable to inhabit — flicker and shine in a dancing, deforming line of light.

La Ribot

With the Distinguished Pieces *project I have tried to place myself in the centre of a slippery surface, surrounded by different concepts and issues that interest me be they dance, performance and visual art, or the popular, the commercial, the political, the social, the feminist or the marginal. In this situation I try to work with the non-definition, destabilisation and the ambiguity of images, meanings and suggestions without any pretension of explanation.*

Piezas Distinguidas *is a project I started in 1993. The inspiration is the body and its movement and the pieces are presented in the form of short solos of between 30 seconds and seven minutes. From the start, my aim has been to produce, over time, one hundred* Distinguished Pieces *and to date three series have been developed, totalling 34 pieces: 13* Piezas Distinguidas, Mas Distinguidas *and* Still Distinguished.

As with any other 'work of art' the distinguished pieces are sold to 'distinguished proprietors' whose name always appear beside the title of their piece, and who are invited to attend the presentation of their piece free of charge anywhere in the world.

Marisa Carnesky

I make performances because I need to externalise my ideas as a 'live show'. I make undressed, anxious, contemplative, showy and unclean work that is not all sewn up and neatly edited. I like to see how people react. I like never knowing whether I'll

fall over or soar. I like the potential for change. Shows change all the time in relation to the nature of different venues and audiences and my own moods and body. Live shows are full bloodied things; they remind you that you are a living, breathing, sweating entity and not another digital image amongst the sea of electrical waves. I like the human touch, the religious ritual — watch me suffer, suffer with me, watch me in ecstasy, lose yourself with me.

Like my work, my body is colourful and crowded: I am burning-building-destroyed-culture-fire-orange, lost-in-the-forest-anxiety-exile-green, carnival-showman-yellow, sweet-smelling-old-lady-nearly-ghostly-lilac, hot-Mexican-pornographic-pink, ostentatious-proud-lucky-peacock-blue, difficult-stubborn-purple and a menstrual-open-wound-dark-coagulated-red.

It was only when I began to research the relationship of tattoos to my Jewish cultural background that I realised that there was something important to me about who and where I came from. Tattoos are taboo in Judaism: according to the Torah and orthodox law you cannot be buried in a Jewish cemetery if you are tattooed. Paradoxically it was my tattoos that brought me back to a sense of my own Jewish identity and this sense was at the heart of my last solo work Jewess Tattooess.

I now see my tattoos as very Jewish in character. My skin is covered in dragons. Dragons made from snake bodies and tiger claws, dog heads, bird feathers and lion manes. Dragons like the Jews are complex and contradictory, cerebral and superstitious, sad and happy and have been all over the place. When I make shows I am like an excavator digging up information that has been buried for decades and I combine it with my experience of the present. I then put it under new lights and in a different order. In my memory I carry fragments like old sepia photos curling at the edges and balancing on the corners of my actual history. Memories of my 70s childhood

are interrupted by seventeenth century Prague or 1930s New York. I can smell the dusty books and cramped, musty praying women up in the gallery. I can see my shoes in the gaslight that spills from the stage of the burlesque dancing girls. I see the illusionist make the woman levitate beyond all questionable doubt. I sit at the seance table and try to bring back the dead.

My shows are always set in Showtime. Showtime is a rare experience of being right here, right now and yet not here at all. Showtime exists simultaneously in and out of reality. My memory of it is vague: I seem to enter a trance where I am just doing, later I find bruises and cuts I don't remember feeling.

My work draws out personal and intimate acts that enter, cut and reveal the body. It tells stories and performs dances. Sometimes people have to take part in an actual experience, sometimes they just watch. I've been making shows as long as I remember and I intend to carry on doing so for as long as I can.

Mat Fraser

My art, in all its guises, deals with my body in a reactive way against society's labelling of it and actively invites a confrontation of perceptions of it, and of me.

Bored with validating my self-perception as art, I'm more interested in setting up an inner confrontation for the audience; seeming to collude with and further propagate stereotypes, whilst simultaneously provoking the audience to question those stereotypes. This applies as much to the disability arts audience, for whom I hold an equal respect, as the non disabled one. I find myself imprisoned between the two, pandering to neither, relating to both, rejected and accepted in equal measures and in different ways that, combined, provide a reality and an overview that I can finally consider.

I've always been aware of the power of the image, certainly in relation to my body. Used as a warning, for pity inducing, for scare tactics, for sympathy, for shock treatment, for fuck's sake by others, and in reaction to the inaccuracies, misconceptions and lack of imagination, I decided to provide a more authoritative signature to further uses of my image by utilising evocations previously hamfisted by others, and claim the territory for myself. At first a victim of, then an exploiter of this phenomenon, I've increasingly used my own image in more and more confrontational presentations, and now find that "telling the truth", rather than being a painful realisation, is in fact fuelling me with outrageously ostracised power. My favourite kind. I'm an outrageously ostracised power ranger, and I've come to kick your face hard façade.

So now, when I approached this project approaching me, my personal journey coincided with Manuel's photography and we colluded in these images of truth, confrontation and Society's naked ambition: to kill my kind(ness).

For me from now the only preparatory process in considering images of me as art is to have my authorship stamped on them. I feel no need to beautify or uglify, to qualify — I'm the real fucking deal. I am porno, I am blood, I am titillation, I am revulsion, I am failure, success and beauty. I am the physical imperfection reflection that offends society's stereotyped sensibilities, for I am a disabled person.

Moti Roti

Embedded within the formality, symmetry and neatness of these images, is a layering of cultural encoding and referencing which parallels our practices. They are at once familiar and unexpected.

Ali Zaidi and Keith Khan have worked together over a ten year period. They are also lovers. Strangely, most people

conveniently see them only as brothers, or related in some way — even after they have explained that one is from Pakistan and the other from Trinidad. They believe this must be because of the cultural assumptions people make. Neither look similar, but to most onlookers, the skin colour alone is enough to immediately turn them into siblings, or perhaps it's peoples' reading of their intimacy. Whatever it might be, it is fascinating that more often than not, it is the object that has to deal with the onlookers anxieties.

So, the pair of artists are painfully aware of this wholesale cultural reductiveness within their practice. In fact, like most non-white people living in the UK, the artists have worked it out for themselves anyway, and their art skillfully plays with the duality; decoding cultural ciphers or making different types of encryption for themselves a recurring feature of their work. The dilemma of creating work in this way is that it is destined to become invisible because the subversion is played out in places that are centred on different groups of people, especially those of colour.

Within Manuel Vason's images there is an overt play with costuming and gesture. Zaidi squats on a chair in a way that Khan, raised in Britain, cannot even attempt, and Zaidi eats with a fork whilst Khan eats with his hand whilst wearing a much more formal dress. The images are disarming and complex at the same time, since they are simultaneously dealing with how the artists are perceived and how they want to be seen. The similarities and differences are all in the same frame.

The artists are not using these influences to deceive or bamboozle the viewer, they are just aware that there can be different readings of the images depending on different cultural exposures. Neither is right or wrong and both are valid. Their work is driving forward the idea that multiple view points, and different labyrinthine perspectives, are now central to contemporary living.

Oreet Ashery

We were best friends, maybe once lovers. When I took myself out of the army, he could not, and so condemned me to a life of exile. He swore that I would be visiting him at a mental institution, bringing home-baked biscuits. On my yearly visits to Israel I would hear his stories about Tibetan meditation and other spiritual quests in the Far East.

A while ago a close friend in Israel became an extreme orthodox Jew and so contact was prohibited. In homage to him, I made a series of photographic stills of myself dressed as an orthodox Jewish man. The black and white stills were the starting point of a visual research into the appropriation of fantasy, desire and play within the framework of my own cultural heritage. Researching them involved following orthodox men in Jerusalem and discussing, with my father, the various dress codes and their meanings. In time the right 'look' was created by diving under cover into Stamford Hill, an orthodox Jewish neighbourhood in London. So was born my alter ego — Marcus Fisher. "Mar-Cus" translates in Hebrew to "Mr Cunt". Marcus finds himself in places where you are not likely to encounter an orthodox Jew, like gay clubs, Soho, the beach and a Turkish men's cafe in Berlin. Gradually these 'outings' became pre-determined interventions.

It occurs to me that since my mother ran away from her orthodox family in Jerusalem, Marcus suggests a queer return to that family.

I/Marcus started then to incorporate performances into the interventions. I became particularly interested in rituals; everyday ones, like smoking, as well as religious Jewish rituals — because of the specific readings they impose on the body. Those performances, connected with Marcel Duchamp's pleasure in the fluidity and play of gender, staged Marcus as a Drag King at times, but mainly, as a transgendered clown, and a wishful cultural mobiliser.

Marcus embodies the Other whilst questioning notions of multi-culturalism, ritual and masculinity. At the same time Marcus is the guy next door; lost and defeated by endless self searching, nihilism and obsession.

I have tried to kill Marcus on several occasions, and in a variety of ways, but he only seems to re-emerge over and over again, shape-shifting. No longer a spontaneous intruder he is becoming an image of himself – a performer and a quizzical art-object.

Like my overall art practice, this body of work is also preoccupied with notions of spectator as participant, and a sense of location embedded in cultural and visceral anxiety.

It's coming back, in dreams, mood swings, and the daily press; a country that will not let go of me. They invited me to perform but got scared at the last minute, and I can not quite recall if I saved the Arab boy, or actually murdered him last night. I am not going to visit this year.

Robert Pacitti

FEAST

Introduction:

The following notes and methods are appropriate for both public or domestic application. All the recipes here can be scaled up or down according to your needs. All measurements are imperial.

A note on ingredients:

Use what you like but always choose carefully. Fresh is best. In recent years we have seen a proliferation of new ingredients to choose from, so be adventurous. Take risks. That said, don't feel pressurised to always adopt the new. Many older stalwart elements retain currency with good reason. Whatever ingredients you select remember, it's how you apply them which is paramount.

A note on utensils:

Scalpels, needles and knives should always be kept clean. Implements for breath restriction, bondage, garrotting and your more general disfiguration needs should be kept close to your chosen working site – for simple ease of access.

A note on your store cupboard:

Obviously this will differ for everyone, but here are some staple suggestions:

Your national flag / a portrait of a loved one (possibly a parent) / a tin of corned beef / a comprehensive selection of explosives / gold leaf / pornography / a sliced white loaf / grass / feather pillows / black treacle / a white rabbit / lasers / a chicken mask / close-up footage of an eye / Class A drugs / a wet wig / maggots / an overhead projector / bricks / a Polaroid camera / string (or rope) / a pig mask / mirrors / the stench of stale piss / and guts (a general assortment of all sorts).

The Recipes:

1) You will need:
An orifice, possibly two
"God Save The Queen" (or your national anthem of choice)
Lubrication (optional)
A string of bunting (I always favour Union Jacks)
A precarious position

The method:
Insert flags into orifice whilst playing anthem. Strike precarious position. Enjoy.

2) You will need:

A glass petri dish

A few maggots (bought easily by the pint)

White paint

A paint roller

An overhead projector

"I Feel Love" by Donna Summer

The method:

Kneel on the floor and using the roller paint your bare
stomach white. Put maggots in petri dish and place on
overhead projector, which should be just in front of you. Play
"I Feel Love" very loud and at Donna's first line quickly flick
projector switch to 'on' revealing shocked maggots twitching
across your belly. Stay in position for remainder of track
(about 3 minutes and 9 seconds).

3) You will need:

A face (use your own if it is appropriate)

Nivea cream

Tissues or a towel

A soft dry paintbrush

4 sheets (approx) of gold or silver leaf

A microphone

A mirror (optional)

A difficult memory

The method:

Cover face with cream (using mirror, if desired). Clean hands
with tissues or towel. Place sheet of leaf onto face, metallic
side down. Smooth out any air bubbles with paintbrush. Pay
particular attention to covering the mouth. Slowly peel off
paper backing. Stand at microphone and engage difficult
memory. Sustain for as long as feels uncomfortable.

4) You will need:

Yourself

Bricks

String

A raised surface

The method:

Tie lengths of string to bricks. Ties bricks to parts of your
body. Stand or lay on raised surface. Display and sustain.

Alternatively you might like to try this:

5) "Recipe for disaster"

You will need:

Yourself

An insignificant distraction

Selfishness (to taste)

The method:

Mix ingredients together. Do fuck all.

For demonstrations of these and many more exciting images
see my practice live.

NOW WASH YOUR HANDS

Ronald Fraser Munroe

These images are visual samples of characters developed over
ten years of theatre, performance and live art. They are
characters who have had a number of manifestations and have
been distributed in many formats — through performance,
photography, the Internet, audio and video, to name a few.

A main concern of these characters is how to impact their
being upon the viewer, to arouse the emotions of those
watching. All of them have addressed audiences bodily and it
is this area of live presentation and interaction that is most
fundamental to my work. To me the body is never a case of
"what you see is what you get" and, so, ideas of race, beauty,

age, power, entertainment or position are always abstract and random. In this age of digital dependence, well-tuned bodies and flabby junk-filled minds it is pleasant to attempt to remind people that priests and police are just other human beings dressed in strange uniforms and that the very word uniformity should set alarm bells ringing. I wonder if audiences are so brainwashed and desensitised by the continuous onslaught of the media that they cannot cope with developing and sustaining an individual politic? It is this that makes it necessary to present satanic priests, drug-crazed literary figures, half-human creatures and right wing zealots on acid. Whilst created as visual media these characters aim at creating a bodily and mental reaction and often stimulate these in the performer.

I have always considered myself to be firstly a writer, yet when developing and writing ideas down I am always struck with a visual idea. There are then, in the creation of a piece of work, a number of 'tracks' running along the creative timeline: visual, emotional, intellectual and aural. Of all these tracks the visual is the one I have been drawn to in the presentation and distribution of work. My body is my chosen vehicle of distribution. I have for many years been interested in the relationship between the senses — and particularly what we see — and our reactions to the visual. In my performance work I have created characters which transform the visual appearance of myself into a fictional being. This character is developed over a period of time, especially through the creation of photographs and digitally manipulated images. Once the characters and his or her psyche are established any situation can be applied to that character to respond to and within. The character takes over my body in order to manifest a story to a viewer. In presenting the physical form of a character I am interested in the various responses from the audience. What do they see? What do they hear? What do they taste, smell and feel whilst with this character? My interest also lies in the inner physical or bodily responses to the character and its dialogues. It is hoped that these bodily responses are retained in some way within the viewer, that a sample of the character and story are taken away from the performance, almost like a virus.

Stacy Makishi

"Love is homesickness" Sigmund Freud, The Uncanny
"Exile always involves a shattering of the former body." Julia Kristeva, Strangers to Ourselves

As I am a transplant from Hawaii, my work is often about love, loneliness, desire and memory told from the point of view of the foreigner. The foreigner confronts us with a projection of our own strangeness, our own foreignness. In all my work there appears to be a tension between here and elsewhere, longing and belonging, desire and repulsion. The body is constantly craving what is foreign, all the while homesick for what is familiar. I think the body, especially when expressed in fragmented or dismembered form, resembles memory. Like homesickness, remembering is how the foreign body reconciles absence and identity. Compelled by a gnawing homesickness, my practice is an attempt to put together fragments of loss; loss of time, loss of loved ones and loss for desire that will never be filled. It is a quest for some kind of unity, nostalgia for a lost wholeness.

Although my work has been mainly text-based performance art, I am currently exploring the possibilities of video, film and animation. The images here are experiments from a multimedia collaborative project, Cinema Bizarre! which arouses images of death, automatons, doubles, halves, and the female sex in a lonely story about three characters who are somehow 'half' in search of being whole. There is a woman who is half-human, half-horse, a lost twin, a hermaphrodite, and a half-crazed woman in love with a double bass. The characters are tortured because they are both aroused and frightened by the foreignness of their bodies and also by the transgressive nature of their desires. They each seek escape from the

isolation and exile which has become a condition of their

secrets, desires and foreignness. They are each like a

lonesome island or like a tiny fist of human frustration. The

women are complicit in their desire to create, through a

series of beauty and scientific experiments, the "love of their

lives". In their desperate attempts to achieve some sort of

wholeness, each character is willing to subject their bodies to

unspeakable horrors.

Susan Carol Lewis

I was born in England. I am not sure really why. I am African,

woman, the rain, a tree, a warrior, English, Vincentian. Above

all, I am spirit in a human form, I am an artist. My belief and

love in humanity and this earth has been the impetus and

inspiration for my creativity. I am interested in the concepts of

energy, the communication with the invisible and how they are

manifested through the body, voice and image. My intention

through the creative process is the expression of our full selves

to uncover who we are and move towards personal and

planetary healing and transformation.

Re:turning Home
Entering the labyrinth through the gateway of the mother.
Holding on. We journey through the terrain. In the midst of
fear, pain and ecstasy we find a pathway. Letting go. We
finally emerge re:membering [an] other world. An ancient place.
Turning back through our very own gateways we return home.
Honouring the journey not knowing where we are really going,
we once again re:member who we are. And maybe for the first
time in this world we know love.

artists' biographies

Aaron Williamson has been active in performance and installation art for over a decade creating 200 or more performances in Britain, Europe, Japan and North America largely informed by the experiences of becoming profoundly deaf. In 1997 he completed his thesis on performance, writing and bodily identity at the University of Sussex and was Fellow in Writing and Contemporary Art at the Ruskin School, University of Oxford in 1998-1999. For the last few years he has expanded his practice to incorporate performance into gallery installations and digital video work. Recent projects include Obscure Display for the Victoria & Albert Museum, Sonictraps, Involuntary Head Sounds for Angel Row Gallery, Nottingham, the touring work Anti-Speak and Gut Corners for the South London Gallery. He has just been awarded the Arts Council Helen Chadwick Fellowship 2001-2002 at the British School in Rome. Publications include Hearing Things (Bookworks, 2001) and A Holythroat Symposium (1993).

Doran George I am finding a life practice of testing out whether, how, where and as what I will live. Performance is integral to this; it is the living of the practice, it demands anchoring it in the conventions of a particular context by contemplating how the conventions of that context are productive and debilitating. That anchoring in turn informs the life practice by forcing it to respond to the world in which it lives. This book is no exception. Contexts where the practice has tried to throw down anchor: geographically located and transient community: local shopping centre, street, train station, tube station. Identity based community: transgender, queer, disabled. Art community: dance, live art, public art, writing and installation.

Ernst Fischer was born in Munich and, while living in Germany, worked with artists Hermann Nitsch and Kim Se Chung. He was a member of Freies Theater München and of Purr Purr Tanztheater (Essen), and studied puppetry at the Deutsches Figurentheaterkolleg in Bochum. After relocating to London in 1978 he co-founded Pink Feet-Warm Bodies and joined several Carnival Mass bands, the David Glass New Mime Ensemble, the Young Vic Company and Gay Sweatshop. Between 1986 and 1996 he staged theatrical events in the front room of his flat in Brixton. For the last five years, he has been concentrating on his work as a solo artist with appearances at the Institute of Contemporary Arts, the London International Mime Festival, the London International Festival of Theatre and venues throughout Britain, Europe and the US. Ernst teaches Asian Theatre Arts/Butoh at Middlesex University London, the University of North London and Goldsmiths College. He is currently writing up his Ph.D thesis on "the queer space of living-room theatre and domestic performance" at Surrey University Roehampton. After finishing his Ph.D, Ernst plans to train as a butler/domestic servant.

Franko B was born in Milan, Italy and has lived in London since 1979. After a Foundation Course at Camberwell School of Art he trained at Chelsea College of Art graduating with a BA in Fine Art in 1990. Franko B has been working across art forms since 1990 in the mediums of performance, installation, photography and video. Recent projects include the performance installation Aktion 398, an installation for Please Disturb Me at the Great Eastern Hotel and Oh Lover Boy — a performance, exhibition, publication, poster campaign and talks series.
www.franko-b.com

Gilles Jobin is a dancer and choreographer of Swiss origin. He has lived in London since 1997 and has been an Artsadmin artist since 1998. In 2000, his became the resident company at

Théâtre Arsenic Lausanne Switzerland. His latest creations are A + B = X *in 1997*, Macrocosm *in 1998*, Braindance *in 1999 and* The Moebius Strip *in 2001. All pieces have musical scores by Swiss musician Franz Treichler, leader of the cult band The Young Gods. Jobin has been awarded the 2001 prize for young choreographic talent by the French Society of Authors (SACD), and his work is touring extensively through Europe.*

Giovanna Maria Casetta is a London based artist working in the media of performance, 8mm film and installation. Her practice is concerned with exploring issues raised around the identity of the individual, especially focusing on the body's conflict between its exterior and interior and how this leads to a misrepresentation of the self. Giovanna Maria's work has been presented in Britain and Europe in a varity of spaces ranging from the traditional to the unconventional.

Helena Goldwater makes predominantly solo performances for a diversity of venues including clubs, galleries, site-specific spaces and theatres both nationally and internationally. She also makes still works and writes for other artists' projects. Renowned for her poetic and humorous use of language and luscious and disturbing use of objects, she has a history of working with fluids and usually makes audiences damp.

Joshua Sofaer is a performance practitioner, a writer and a university lecturer. He makes live interventions in gallery spaces, theatres, nightclubs, private houses and wherever else necessary; he makes written interventions in magazines, journals, newspapers and books; and he gives lectures, seminars and workshops in univeristies and art colleges. The works vary significantly according to the specifics of event, audience and site, but are all grounded in a critical practice which nevertheless employs humour as a fundamental strategy for the communication of ideas and theories.
www.joshuasofaer.com

Kira O'Reilly is a visual artist whose work to date has primarily used performance to investigate notions of the gendered body, both its materiality and as a site. Since graduating in 1998 she has shown works throughout UK and Europe. She has been the recipient of four commissions and most recently an Artsadmin Bursary and a South West Arts Visual Art award. Her current research is grounded in practices of drawing and painting investigating a fragmentation of the body in relation to notions of site.

DogonEfff is an artists' organisation set up by Andrew Colquhoun and Maria De Marias to incorporate live performance and video with the new streaming media technologies of the Internet. DogonEfff seeks to put the Internet into the real world via livestream video installations and experimental performance programmes, whilst retaining and confronting a feeling for what is basically human in the disincarnation of speed and the new systems of telematic communication.
www.dogonefff.org

La Ribot started creating her own choreographic work in 1985 in Madrid, where she founded Bocanada Danza with Blanca Calvo. In 1990, she began a new period with different processes and artistic disciplines and produced Socorro! Gloria! *(striptease), 1991,* 13 Piezas Distinguidas, *1993-1994, and* Oh! Sole, *1995. In 1997 La Ribot moved to London where her work has expanded freely between visual art, performance, live art and dance, and has been presented at major international art galleries, theatres, dance festivals, live art and performance festivals. She has toured the world with two award-winning series of distinguished pieces* Mas distinguidas, *1997, and* Still distinguished, *2000. She has also produced a group work* el gran game, *1999, and work for other dance companies, such as* Ricochet. *In 2001 she started working with her own video projects and began research for another group piece,* Los Juanes *to open in 2002.*

Marisa Carnesky has been making work for just over a decade including performance actions, choreography, storytelling, illusions, video and film projections. Her work has been solos and collaborations presented in a variety of spaces from theatres, galleries, synagogues, nightclubs, alleyways and striptease theatres. Her last solo work Jewess Tattooess has been shown nationally and internationally and her new group work Carnesky's Ghost Train is currently being developed for 2003.

Mat Fraser works as a visual, performance, theatre and music artist. His self produced work includes co-curating the Wrong Bodies exhibition and performance at the ICA, London, 1999, and the forthcoming Wrong Bodies: The Skinflick and Wrong Bodies, the book. As a performer he has presented Teratostestament for Wrong Bodies, The Mutant Suitor Versus The Revenge Of The Squid Woman for Duckie, 1999, and three different pieces for Hydra Live Art Club including Bull Metal Jack Off, 1998-1999. For the theatre he has written and performed a touring one man show Sealboy: Freak, 2000-2001. His LP Survival of the Shittest was released in 1999 and the EPs Genetically Modified... Just For You and Perfectly Deformed in 2000. Mat co-wrote, and was the subject of, Freak Fucking Basics by Jo Pearson, 1995.
www.matfraser.com

Founded by Keith Khan and Ali Zaidi in 1991, *Moti Roti* is an award winning artist led organisation that celebrates individuality and diversity through art. They produce an eclectic mix of live art, experimental theatre, installations and time based works such as recent projects Plain Magic and Fresh Maasala. Moti Roti's aim is to produce work informed by a global cultural aesthetic which tackles contemporary issues and challenges art form definitions. The scale of many of their projects, such as Flying Costumes, Floating Tombs, is epic and visionary whilst other projects, including Wigs Of Wonderment, are small scale and crafted for the individual. All of their work is distinguished by being visually seductive, sensitive to space, participatory and transformative.
www.motiroti.com

Oreet Ashery is a London based artist. Her interdisciplinary practice encourages a dialogue between performance, interventions, video, digital acts, sound, photography and text. The work is shown and happens internationally in galleries, cinemas, clubs, homes, the streets, live art and film programmes. Oreet is interested in the slippage between art and life, the status of small rituals, further mutations of current art practices, and notions of the site-specific event with audience as participants. Her work uses politics of the body in relation to culture and location.

Robert Pacitti is a London based artist working primarily in multi-disciplinary performance theatre. He has been showing his highly acclaimed award winning group and solo work internationally for over a decade. Having initially trained in painting and theatre he now engages a wide range of making processes in order to generate research driven work including writing, sound based, film and photographic outputs. He currently lectures in 'Advanced Practice' at Cheltenham College of Arts.

Ronald Fraser Munroe is a London-based writer, director, producer, performer and graphics-video artist. His multi-media and cross platform work encompasses text, theatre, audio, photography, movement, video and the digital arts and is distributed throughout the UK, Europe and the US. He is concerned with new models for contemporary arts practice, individual empowerment and the political aspects of creativity.
www.k3media.demon.co.uk

Stacy Makishi is a London-based performance artist from Hawaii, whose work often festers in the crack between fear and desire. Currently, she's obsessed with film, video, animation and peanuts. Her latest multimedia works include: Suicide for Beginners, On the Street Where You Live and Eat More Spam. She has just completed a world wide tour with Salad of the Bad Cafe with Split Britches. She is Co-Artistic Director of a multimedia company called runt and is working on a new piece called Cinema Bizarre!

An artist, teacher and healer, **Susan Lewis** has been creating and performing work in the field of Live Art for twelve years. Her unique collaborative style has been recognised nationally and internationally and she is the recipient of several awards and commissions including a Time Out/Dance Umbrella Performance Award, an ICA commission and the Bonnie Bird choreographic award. Her performance works include Walking Tall, Ladies Falling and The Minnesota Coat. She has worked as a movement specialist and choreographer for several theatre companies, created digital media works and facilitated a number of creative community development projects. Susan's work is process based and ritualistic in nature, integrating movement, voice, text and multimedia. Her earlier works were placed in theatre venues and art galleries, she has more recently began working with creativity, performance and nature.

Manuel Vason was born in Padova, Italy in 1974. Whilst studying at the University of Social Science, Padova, he decided to become a photographer and moved to Milan. He found a job as a studio assistant at Industria Superstudio where he worked for two years with some of the most highly regarded photographers in the fashion industry. In 1998 he moved to London and whilst assisting the photographer Nick Knight started working beyond the limits of fashion photography. He recently collaborated with Franko B on the Black Dog book Oh Lover Boy.

Lois Keidan is the Director of the Live Art Development Agency, London. From 1992 to 1997 she was Director of Live Arts at the Institute of Contemporary Arts in London and prior to that she was responsible for Performance Art and inter-discplinary practices at the Arts Council. As an independent curator her most recent projects include Small Acts At The Millennium and Skin Deep, a programme for De Beweeging in Antwerp, Belgium. She contributes articles on performance to a range of journals and publications and regularly gives talks and presentations on performance at festivals, colleges, venues and conferences in Britain and internationally.

Ron Athey is a performer and writer living in Los Angeles. From 1991 to 1999 Ron Athey & Company extensively toured Martyrs & Saints, 4 Scenes In A Harsh Life and Deliverance. Since then, Athey has toured the collaborative work Incorruptible Flesh and the solo work The Solar Anus. He is currently working on Joyce, a performance/four screen video piece. His writing has appeared in The Village Voice, Details, Virus Mutation, Honcho, and several anthologies including Unnatural Disasters, Strategic Sex, and Acting on AIDS. He is a regular contributor at the LA Weekly, writing about arts and culture. www.ronathey.com

The Live Art Development Agency is an independent organisation run by Lois Keidan and Daniel Brine, offering a portfolio of services and schemes and a range of initiatives for the support and development of Live Art in London and beyond. Part research tool, part training ground, part advisory service, part broker and part lobbyist, the Live Art Development Agency particularly champions the 'high risk' artists, practices and ideas of new performance and time based work. The Live Art Development Agency is funded by London Arts. www.liveartlondon.demon.co.uk

Published in association with the Live Art Development Agency

Photography by Manuel Vason

Edited by Lois Keidan and Daniel Brine

Produced by Duncan McCorquodale

Designed by Joe Ewart & Niall Sweeney for Society

Many thanks to all the contributing artists, Ron Athey,

Mark Waugh at the Arts Council and Lisa Cazzato

Financially assisted by the Arts Council of England

Black Dog Publishing Limited

5 Ravenscroft Street

London E2 7SH, UK

t: +44 (0)20 7613 1922

f: +44 (0)20 7613 1944

e: info@bdp.demon.co.uk

Black Dog Publishing

Architecture Art Design Fashion History Photography Theory

and Things